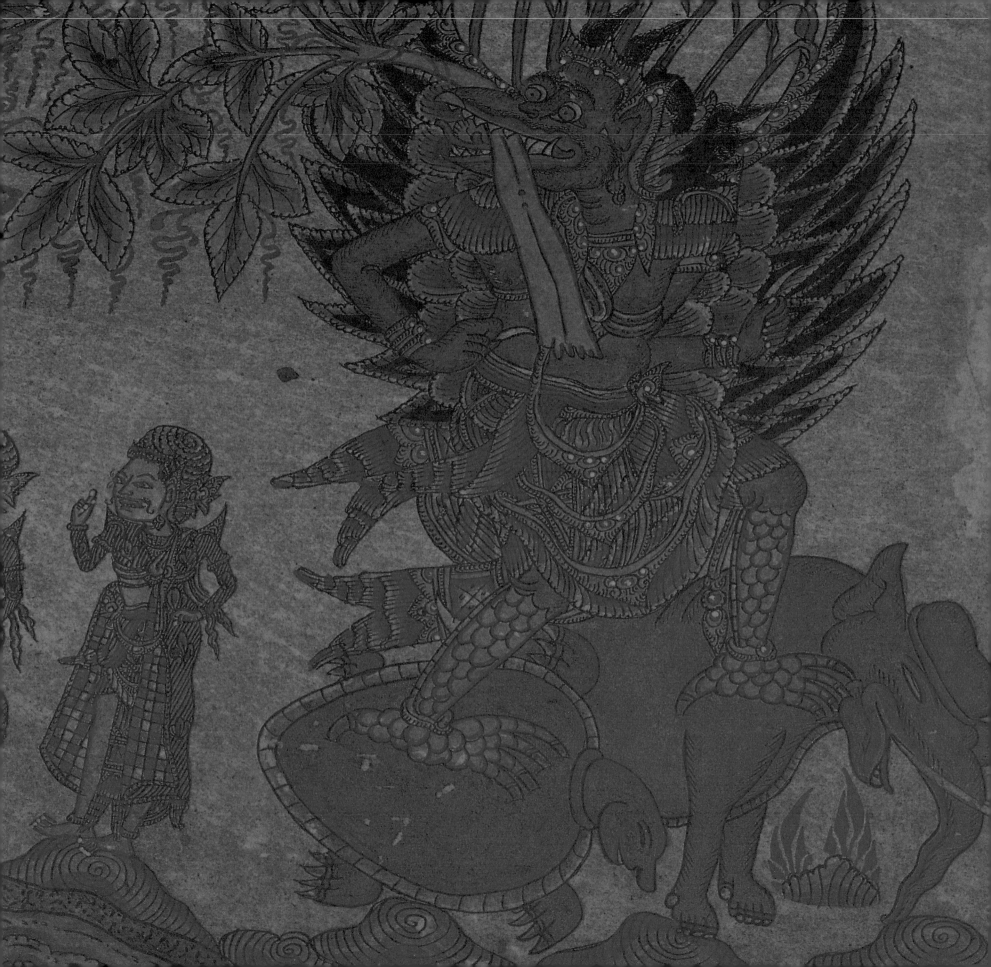

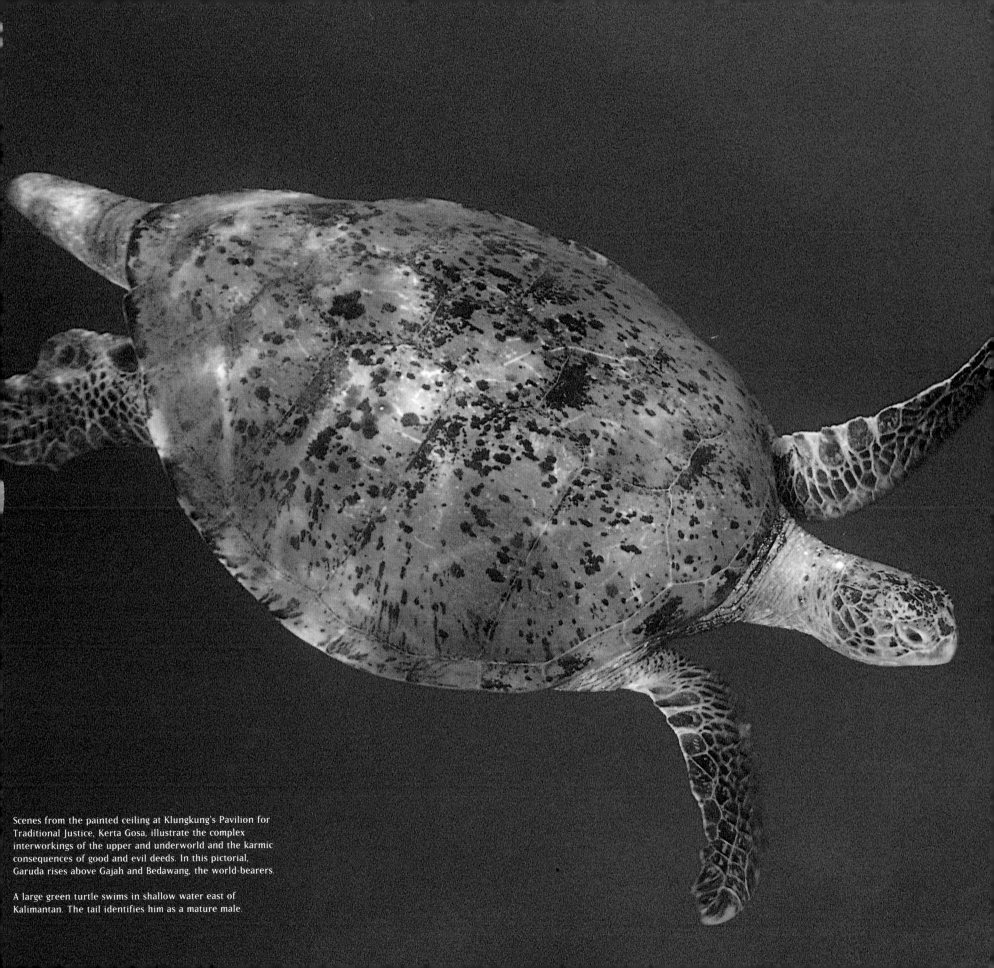

Scenes from the painted ceiling at Klungkung's Pavilion for Traditional Justice, Kerta Gosa, illustrate the complex interworkings of the upper and underworld and the karmic consequences of good and evil deeds. In this pictorial, Garuda rises above Gajah and Bedawang, the world-bearers.

A large green turtle swims in shallow water east of Kalimantan. The tail identifies him as a mature male.

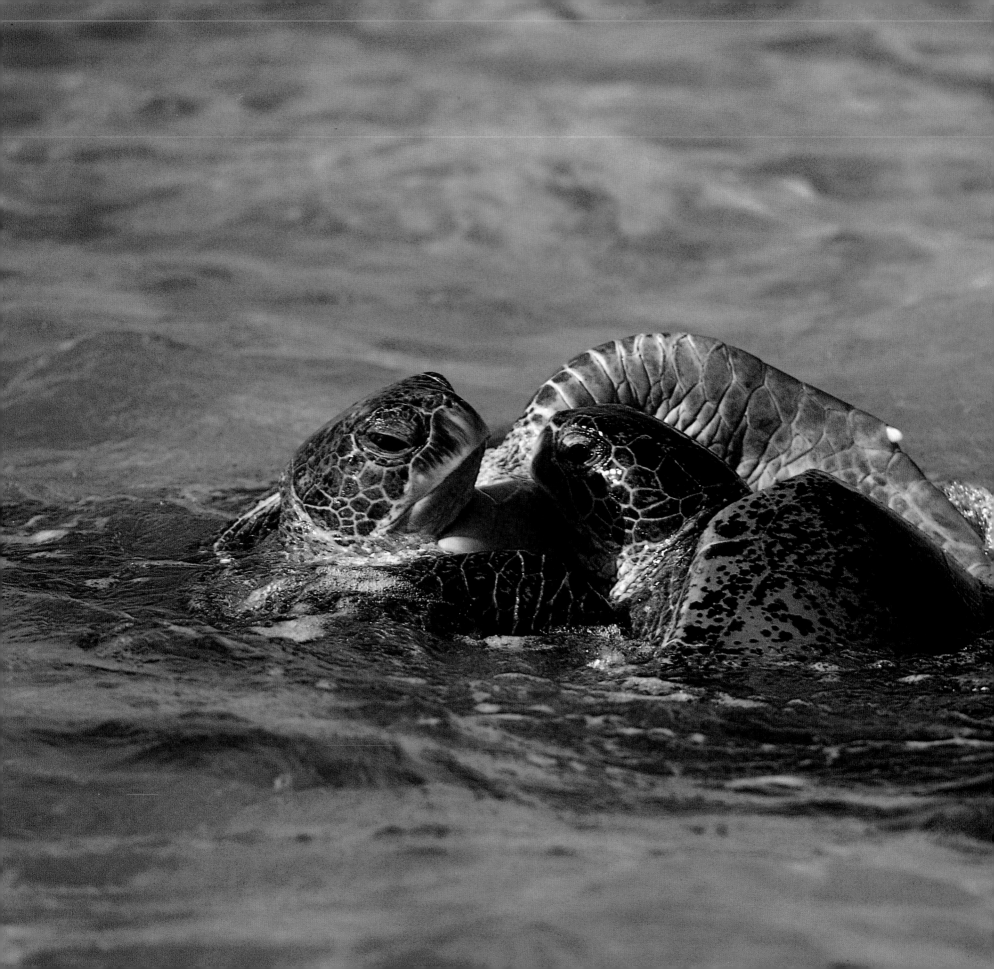

TURTLE ISLANDS

During mating season east of Kalimantan, a pair of adult
green turtles nuzzles affectionately just prior to separating.

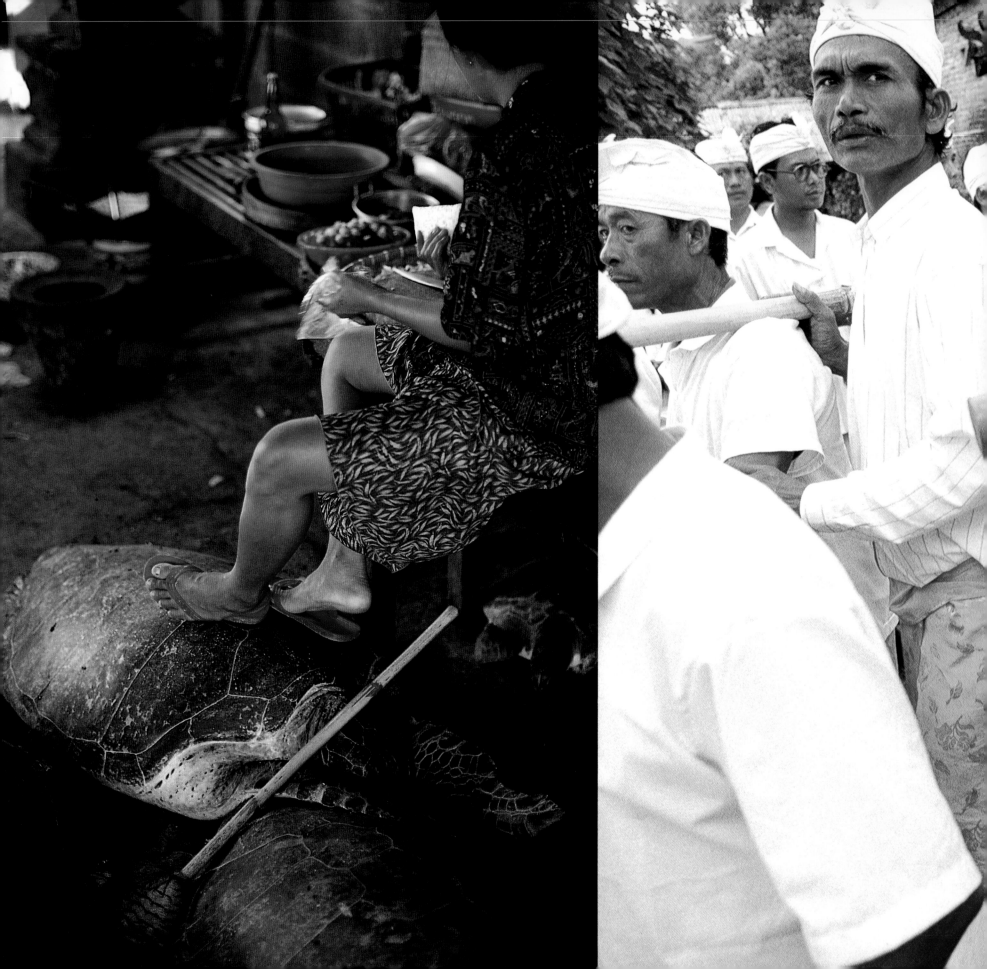

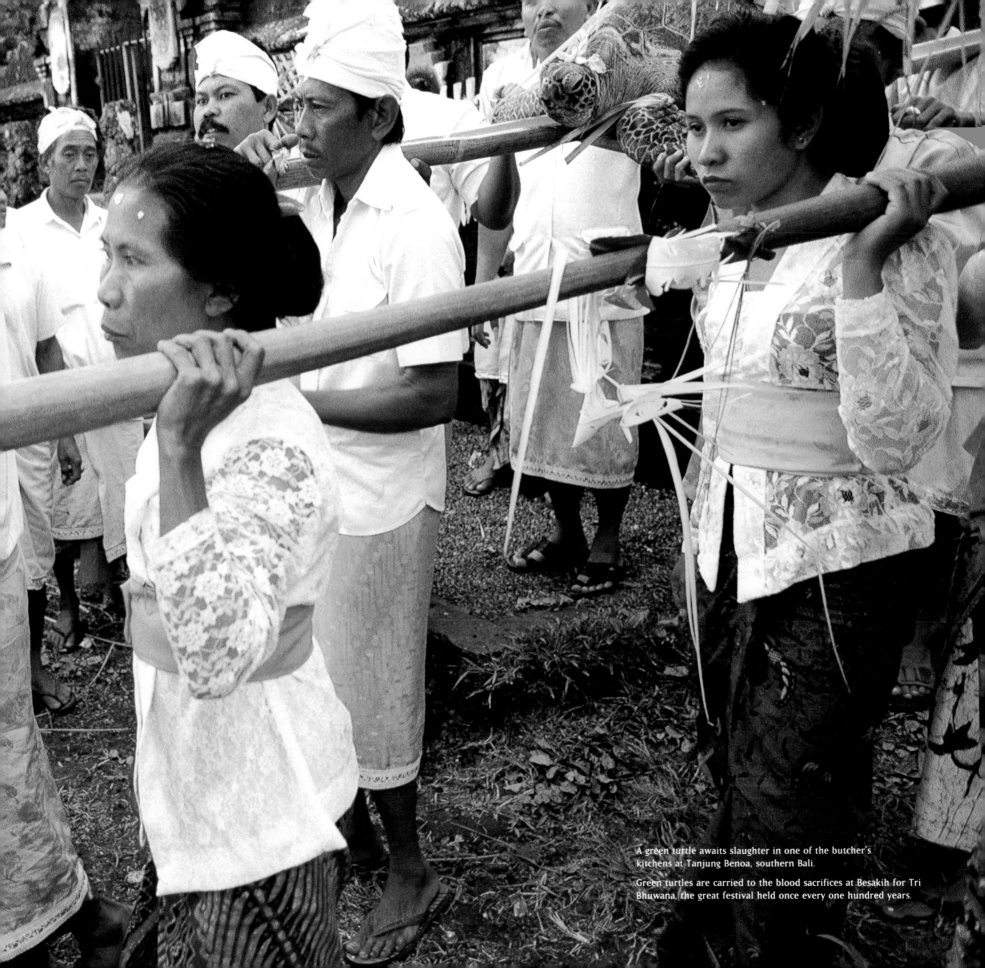

A green turtle awaits slaughter in one of the butcher's kitchens at Tanjung Benoa, southern Bali.

Green turtles are carried to the blood sacrifices at Besakih for Tri Bhuwana, the great festival held once every one hundred years.

TURTLE ISLANDS

Balinese Ritual and the Green Turtle

Photography and Journals by Charles Lindsay
Essay by Lyall Watson

Takarajima Books

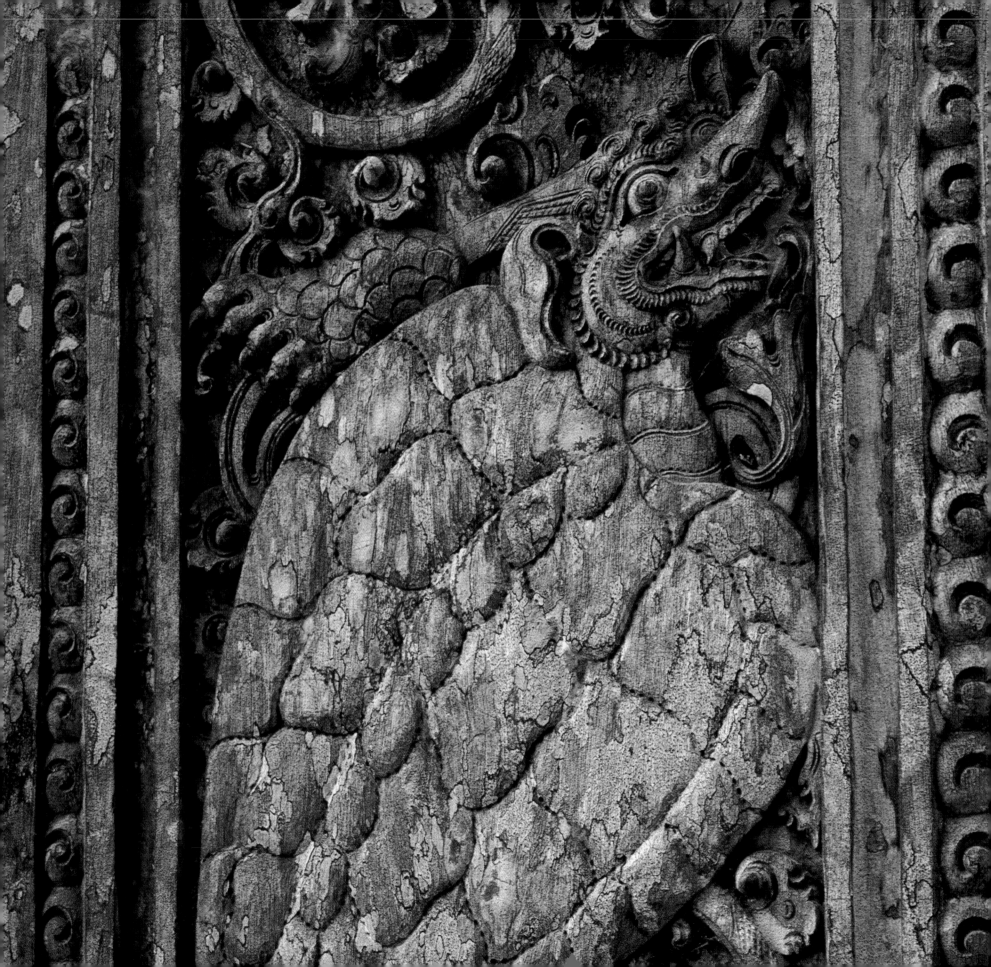

Essay
By Lyall Watson

We are the pattern-makers, the watchers of the world, sorting through the entrails of the earth in an endless search for meaning.

It has always been this way, as though consciousness carries with it the penalty of a pressing need to know.

So we look for signs in everything, reading nature like a book, hoping always to come across some sort of message hidden between the lines. Some clue, some hint of direction, anything that will make it easier to understand who we are and what on earth we should be doing.

There are no easy answers.

Once in a while someone comes up with a new user's manual, the inside story, a set of instructions that lay down the law. But more often than not these are couched in parables, in images sufficiently ambiguous to provide employment for the hordes of rishis and roshis, priests and shamans, whose task it is to make the message clear.

Some are very good at it, masters at the art of weaving patterns that please, that satisfy the needs of their time and keep anxiety at bay. But the most interesting thing about all such belief systems is that hidden between the phrase-making and the wishful thinking are a handful of essential themes that appear to be universal. And the most common and potent of these is that, "in the beginning," every bird and beast, every tree after its kind, even the earth itself, rose up out of a primordial sea.

It is unusual for oral traditions from so many sources to be in agreement. In fact, it is so rare to find such harmony in anything at all to do with human affairs that it becomes tempting to conclude that these insights really do represent something more than poetic license. And that we were truly once waterborne and struggled, along with a variety of other hopeful organisms, to haul ourselves ashore.

Accounts of this great transition vary.

The Andamanese, with a fine disregard for evolutionary niceties, have it that a joint of bamboo came floating in from the sea and that from it, like a bird from its egg, crawled an infant, the first human, whose name was Jutpu—"Alone."

Door detail of Bedawang Nala at Pura Kehen temple in Bangli.

Others reach for geological perspective, calling on the services of a primal middleman, an "earth fetcher" whose task it was to establish an area of dry land in an otherwise watery early world, setting up a beachhead toward which the grand migration could go.

There seem to have been a number of such busy world-builders. Among North American Indians, the most active was believed to have been the loon or the red-throated diver. In Central America, the Caribs gave their credit to the ibis, while in South America, honors went more often to the homely moorhen.

In most cases, these feathered fetchers had help—calling on fish, frogs, beavers, otters, and muskrats to carry the quantities of earth needed to establish a stable foothold. In the Hindu Puranas, it is the great god Vishnu himself who lends a hand, assuming the form of a giant boar who dives heroically into the cosmic sea. But whatever the agency, the result is the same—earth is found and heaped up upon itself until it rises from the sea.

For some myth-makers, this was enough. Land was created and the occupation could begin. Others—probably those weavers of words whose audiences demanded more convincing narrative detail—were left to fill in the logical and scientific gaps, and come up with the comforting notion of an additional agent of creation. Someone who could, more convincingly, bridge the gap from water to land, providing purchase for unstable muds, supporting the early earth literally on its own broad back. And everyone, everywhere, turned with relief and complete conviction to that doyen of all world-bearers—the turtle.

There is, it is true, some confusion (of a kind that still exists today) between turtles and tortoises. Naturalists recognize some two hundred and fifty living species of shelled reptiles, the last survivors of a group that made the slow leap from water to land and paved the way for dinosaurs to become the dominant animals on earth. Those flashy extroverts are now long gone, but the pioneers that preceded them persist, living still in all seas and on every continent except Antarctica, protected largely by their domed carapace of fifty jigsawed bones covered by a scute.

The terrestrial ones are best known as tortoises. Some more or less aquatic freshwater forms have been called terrapins. But, along with the seven surviving marine species with paddlelike flippers, all are nevertheless true turtles and valid candidates for the honors of world-bearing.

Supporting the earth is not a passive task. The turtle, it seems, was not conscripted, punished for some ancient shortcoming, to bear the heavy load forever. By all accounts, it appears to have been a volunteer, assuming the responsibility simply because it was the best candidate for the job. And doing it well on the whole, though liable from time to time to remind the rest of us of its presence by bouts of restlessness that produce earthquakes and floods.

Turtle iconography is global. Stones shaped and patterned like domed shells are as likely to be found in the foundations of Turkish monuments as they are in Mexican pyramids. But the concept seems to have evolved in ancient India, appearing in pre-Brahmanic creation myths that describe the turtle's raised back as the bowl of heaven, and its flat underside as the earth.

The Hindu honorific for the turtle is kurmas—"the curved, the humped, the eminent"—a description applied also to Vishnu in his second incarnation, the one in which he stirs up the ocean to make ambrosia. In later Buddhist versions, the maker and supporter of the earth is identified as Bodhisattva Manjucri, who also turns himself into a turtle.

And where similar beliefs are held among Central Asian prairie dwellers, such as the Ugrians and Yakuts, it seems clear that these understandings have come from the south, from the tropical Indian Ocean. The rest of the myth, however, appears to have more to do with montane spirituality than coastal ecology.

Rising from the turtle's sturdy back grew a many-storied world pillar, most often shown with seven levels—beginning with the turtle; passing upward through the elephant (sometimes seen as a rival in the business of world-bearing); on to a sacred bird; then to a mammal (most often the cow); with man above this on the fifth level; supporting in his turn a priest or shaman; on whose shoulders finally rest the gods.

The details differ, of course, from place to place.

The longer horizons of the Altai Tartars led them to expand these seven stories of the sky to nine, and by the time the myth reached the northern Ostiaks, the cow or water buffalo had naturally evolved into a reindeer.

But these are geographical quibbles. The fact remains that levels of spiritual growth, or steps to be followed in the process of reincarnation, or patterns of cultural or social seniority—wherever such notions may occur—can all be traced back and down to one wonderful common denominator. To the immortal turtle, which persists even as the earth rushes headlong into ill-considered change; which comes ashore again and again on a rising tide, reenacting our ancient history for us, weeping as it does so, reminding us of our origins in, and our continuing dependence on, the world ocean.

There is something extraordinarily moving about the sight of a great turtle coming ashore. She arrives in her proper season, nearly always after dark and seldom when the moon is full. She chooses her moment when the tide is high enough to bring her close to an ancestral nesting site and then strands herself deliberately, bumping softly on the sand. Taking her time, making up her mind.

This is always a tricky moment, a pause on the brink of what could be a fatal commitment. Any movement on the beach, any stray light or sound, will send her lurching back into the deep.

The caution that accompanies that first contact with the shore in years is great. But the urge to nest is even more compelling, so she lets the surf wash over her for a while, rising with the water, blinking and peering to left and right, nuzzling the beach as the waves retreat, testing its taste and consistency, matching it perhaps with something in her memory that lets her know she has arrived at the proper place. Then eventually, if nothing untoward occurs to make her change her mind, she digs in her huge

oarlike flippers and drags her unaccustomed weight laboriously ashore, away from the familiar support and safety of the sea, into an alien environment that has become more dangerous to her with every year that passes.

She lumbers up the slope of the beach, flapping and hauling, heading for the dry windblown sand beyond the reach of the highest tides. Here, on the edge of the dunes, where hardy salt-tolerant plants mark the outer limits of the land, she stops and stakes her claim and sets in motion one of the most single-minded, self-sacrificing patterns of fixed behavior in the entire animal kingdom.

From the moment the sequence begins, the nesting turtle is oblivious to everything around her. It is as though she is entranced. She scrapes and turns, hollowing out a pit larger than her body, finally using her hind feet alone in the most wonderfully delicate way to shape an urn, into which she lays close to a hundred spherical eggs encased in shells of soft white parchment.

All of which may take an hour or more, and goes on without regard for people waving torches, flashing cameras, sitting on the turtle's back, or stealing the eggs directly from her ovipositor. And when she is done, with or without an audience, she fills the nest, covers the pit, and conceals the entire site with sprays of sand thrown vigorously about by her long front flippers before making her way painfully back to the sea.

By the time she turns to leave, the tide has begun to ebb, and the returning arm of her caterpillar track is always longer. It certainly seems so, as she gasps with exhaustion and the effort of having to deal with gravity for so long. Watching her is a heartbreaking business, a potent reminder of the relentless nature of life and of how much of creation has taken place right here in this marginal world, this area of perpetual unrest, where sea and shore meet and neither quite holds sway.

It was here, sadly, that turtles and humans first met—one returning to the land to breed, the other going back to the sea to feed—and it was clear from the outset that this contact across two hundred million years of evolution could have only one outcome. The reptile was just too easy to turn turtle. Too easy to catch and kill when it came ashore, as it has to come ashore, to reproduce. And herein lies a strange and compelling irony.

Reptiles were the first vertebrates adapted to life in dry places; the first four-limbed animals to become truly terrestrial, with eggs designed to resist moisture loss. This adaptation alone made it possible for them to spread out into totally new areas, adopting a wide variety of new strategies—one of which was to protect their soft body parts by enclosing these in a tough shell. This particular ploy proved so successful that it was retained when some pioneers turned their domed backs on the land and went to sea again, neatly armored now against the attacks of predatory fish.

Life was good for the first marine turtles. It still can be because, as adults, they have few natural enemies in the ocean. But there is a catch. There always seems to be in matters of evolution, one of whose rules is that you can never really go back again. Change is irreversible, and the sea turtles, for all

Skull of a green turtle found in the scrub above the waterline on Sangalakki Island, east Kalimantan.

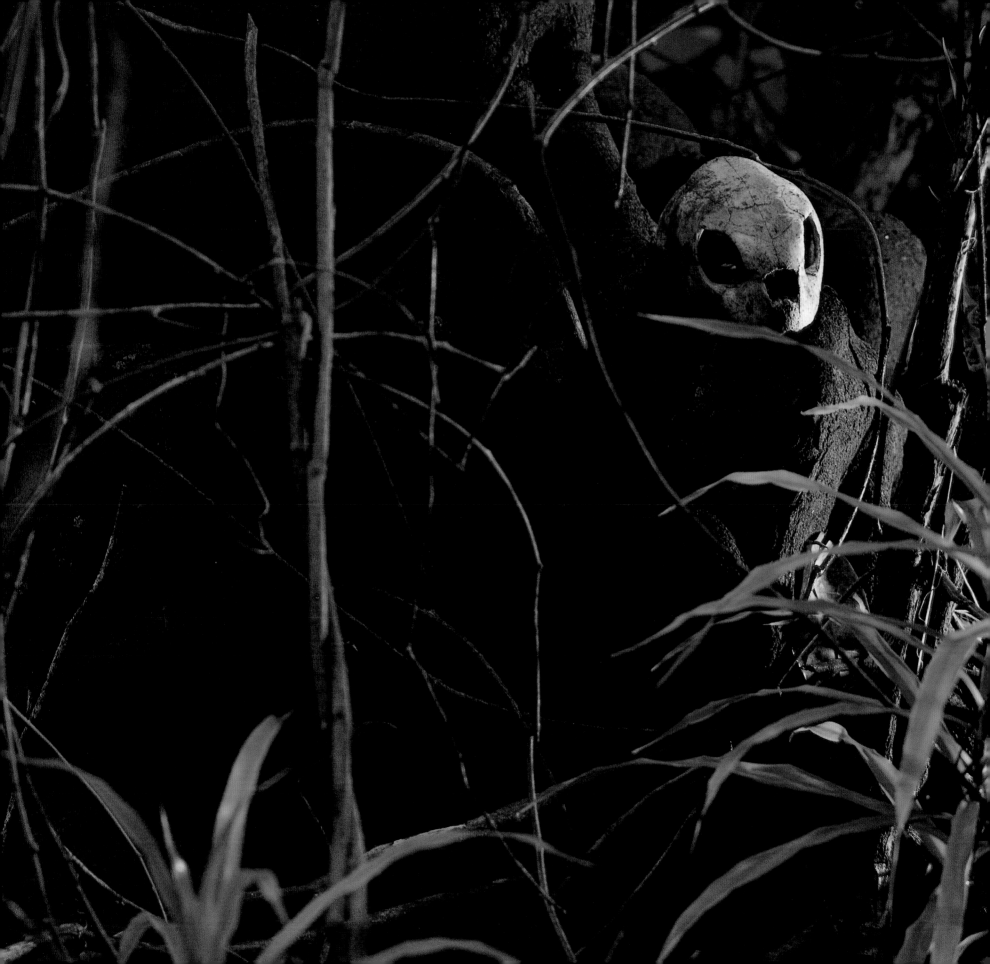

their success, are condemned forever to put themselves at risk by laying their clever new eggs in the environment for which these were intended—on land.

We have a similar problem. We take pride in the fact that we differ from other animals in our brain size, our powers of reasoning and speech, and our extraordinary dexterity. We feel fairly certain that these talents were acquired recently, somewhere between leaving the trees and inventing the wheel. And, when we think about it, we suspect that these things might have something to do with the fact that we are also hairless and bipedal. But nobody knows quite how and why that happened.

It has not been altogether a good thing. The downside of being upright is that it shortens our spines, putting so much pressure on the lower back that this becomes unstable and easily injured. Our peculiar posture also packs all our entrails into the lower belly, and more blood than we need into our legs, leading to hernias and varicose veins. And being naked not only is embarrassing, but exposes us to sunburn and skin cancer. So why did we do it? No one can say for sure, but there is only one possible theory that fits all the facts.

Somewhere, around six million years ago, perhaps in a time of flood when other food was scarce, our ancestors found it necessary to spend a great deal of their time in the water, where walking upright wasn't just an evolutionary option, it was a necessity. If you didn't, you drowned. And when you did, there were no immediate disadvantages. Water took the weight off the lower back, the pressure off the abdomen, and prevented pooling of blood in the legs. It also deprived us of our fur, which was useless when wet, giving us instead a layer of streamlined, insulating fat under the skin, just like a dolphin.

Being aquatic also, arguably, freed our hands and minds for higher things. Unable to bring our noses down to investigate the world at our feet, we took instead to bringing bits of it up into the air, peering at them right in front of our faces, and soon fell to discussing such finds with other wading apes similarly occupied.

"Hey, come and look at this!"

Living was easy on those tropical shores. The problems became apparent only when we walked out of the shallows to put our new talents and our bigger brains to work on the challenges of living on land again. And on the way we met the turtles, going in the opposite direction, struggling with their own difficulties at the interface—and something passed between us. The recognition of an affinity, something in the eyes perhaps that still strikes a chord in us, but it wasn't enough to stop us from flipping them over on their backs anyway—just in case we got hungry later. Something we usually do, more and more often recently as there are more of us around. And unfortunately for them, turtles make very good and easy eating.

Beach dwellers everywhere count on them each breeding season. An adult female turtle, depending on its species, lays between two hundred and one thousand eggs every two or three years. Many of these are dug up and eaten almost immediately by racoons, skunks, cats, dogs, pigs, rats, badgers, crabs,

ants, vultures, and people. In prehistoric times, a delicate balance existed between such predation and the number of eggs a turtle could afford to lay. But egg gathering for the hungry human markets of Asia, Africa, and Latin America has disturbed the equilibrium so badly that the number of turtles laying anywhere has gone into a disastrous decline.

But if the breeding beaches are patrolled and protected, if nests can remain undisturbed for just a few days, then wind, sea, and sun conspire to conceal their whereabouts very effectively for the six to eight weeks it takes hatchlings to decide whether they are to be male or female, and on which soft midnight they will choose to erupt together into the open air.

The minute or two that follow their explosive emergence from the nest are the most dangerous ones in a turtle's life. All the predators that were drawn to the egg-laying gather again between the tides, forcing the hatchlings to run a terrible gauntlet of claws, beaks, and teeth. A challenge they meet by coming into the world so tightly wound that they scramble down to the water's edge like manic clockwork toys.

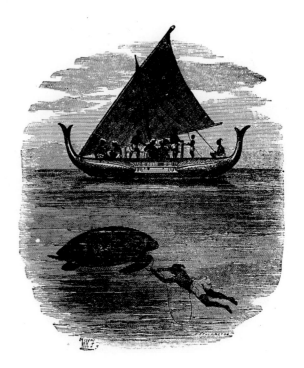

There is something of the same desperation in the movements of the nesting female on her way back to the ocean, something resolute and awkward all at the same time. An admission of evolutionary disadvantage, of form and habit so drastically modified for success at sea that the last remaining link with land has become a liability. And that link is now made lethal by the presence on the shore of a predator who not only hunts turtles directly at every opportunity, but who unthinkingly destroys their nesting sites and nets them idly, making turtles going to and coming from the beaches incidental casualties of another industry.

The world-bearer seems doomed to bear the brunt of having established a beachhead firm enough to give footing to a less specialized, more destructive species. And nowhere is this conflict between the old and the new, the myth and the reality, more poignant than in the islands of eastern Indonesia, where people live like sailors, always within sight of the sea, taking much of their sustenance from the ocean but turning their backs on it too as, like the rest of us, they reach instead for the stars.

In Bali, whose people call their home "The Navel of the World," the island is seen as the center of an orderly universe that rests, naturally, on the back of a turtle known as Bedawang Nala—"The Stabilizer"—who floats on the world ocean. His image can be found at the foot of shrines to the sun god and at the base of every cremation tower. On Bedawang's back rests a black stone covered in mud, which has dried to make the fields and the mountains. Above this is the floating sky of clouds and weather; another dark blue sky, which supports the sun and the moon; a perfumed sky filled with stars; the flaming heaven of the ancestors; and, on the seventh level, the arena of the supreme being, Sang Hyang Widi.

This vertical sequence comes naturally to a people confined to a narrow fertile plain that lies between soaring volcanic peaks and the planet's deepest ocean trenches. To them, everything in nature has a rank and a place. Things are either up or down. Not north or south, but upstream in the direction of the great mountain Gunung Agung, which is visible from almost everywhere in Bali, or downstream toward the encircling sea.

Holiness is synonymous with height. The mother temple of Besakih lies almost a thousand meters above ocean level, high on the slopes of the sacred volcano. The tallest cremation towers, those with as many as eleven roofs, are reserved for royals and Brahmanas. But the ashes of every caste are finally purified by being taken back down to the coast and returned to from whence they came, to the sea.

In all this, the Balinese are very conscious that their place lies in the space between the two extremes. And that to hold this middle ground they must dedicate themselves to reconciliation and harmony between high and low, day and night, good and evil, life and death. Which they do by building spiritual bridges, by prayer and ceremony, by music, dance, and song. And, most important, with offerings of food and flowers and the sacrifice of very special gifts—the most potent and expensive of which has always been a turtle.

At the mouth of Benoa Bay, Bali's best harbor, lies the island of Serangan—the home of Dewa Baruna, the deity of the sea. Twice each year, on days when the moon is just a thread of silver in the sky, the tides are low enough to make it possible to walk across exposed sand flats to the island. Then thousands of Balinese do just that, carrying giant puppets in procession to temples decorated with slender pyramidal shrines called candi. Some of these are balanced on the back of a carved turtle, which is appropriate, because Serangan is also known as "The Turtle Island."

In shallow water on its lee shores are roofed palisades holding hundreds of green turtles captured during the breeding season in December and January, and fed and fattened there for feasts throughout the rest of the year. Some of these take place at Pura Sakenan, the old sea temple, but the pens also supply turtles for festivals all over Bali. They always have, and as turtles have become more scarce, their price has risen. But so has demand, because their value as sacrificial offerings has increased in direct proportion to what a worshiper must pay. So new commercial pressures have been added to the traditional ones that already make world-bearing so onerous.

It is sad that this should be so in Bali, where life and faith are centered on concepts of harmony and equilibrium. But it is perhaps not so strange when one knows that most Balinese worship according to the traditions of Agama Hindu, in which Siwa, or Shiva—"The Destroyer"—plays a dominant role. Theirs is a cosmos in which good is honored, but evil also has to be recognized, placated, and accepted. Unless both are taken into account, happiness and contentment become impossible. Without demons there can be no divinity. Without sacrifice, without honor, no gain. And in Bali, at least, no turtle dies in vain.

The sad truth, however, is that turtles in Balinese waters are now so rare that hunters working for merchants there must roam to Timor, Aru, Tanimbar, the Moluccas, and even Irian Jaya to find enough turtles to meet the ceremonial needs of Bali's busy religious calendar.

There is an ancient manuscript called the Catur Yoga, in which the world is seen to be bound to Bedawang's back by a pair of crested serpents, or naga. And this description very clearly carries with it a warning that when the snakes are allowed to lose their grip, for whatever reason, earthquakes take place with devastating consequences.

Since the turn of this century, Bali has undergone the cultural equivalent of a major quake, and somehow managed to ride out the storm. A skillful blend of innovation and tradition, new tools and ancient arts, modern ideas and historic customs, has allowed Bali to keep much of its special flavor. The people of all the islands are expert at such social juggling, but how long, one wonders, can they really afford to ignore, and go on conniving at, the destruction of a species that, in their own belief system, symbolizes the foundation of life itself?

Are they resilient enough, and wise enough, to set the rest of us an example and find some way of reprieving the turtle? Or are these animals simply too special altogether not to be doomed, perhaps even deliberately chosen, to share in our pain?

Maybe, in the end, all such questions and concerns are meaningless. Turtles saw the dinosaurs come and go. They may outlast us, too.

While they still exist, there is reason to be thankful. We owe the turtles much.

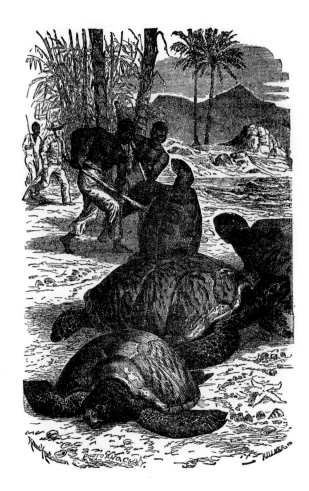

It might seem in retrospect a poor exchange, but without the great fleets of green turtles that once grazed in the clear, shallow waters of all the tropics, there would have been no human exploration of areas beyond the span of perishable supplies. Like the trade winds, turtles extended our reach. And like manna, they were there for the taking—abundant, tasty, easy to find, and simple to catch even outside the breeding season. No other fresh food was ever so portable, so conveniently packaged, or clung so long to life on their backs in the holds of sailing ships.

Turtles have a place in human history almost as large as that of the horse or the camel, but without the honor of either. Which is a pity, because in addition to their beauty and utility, turtles offer us something every bit as important. They are rich not just in myth, but also in mystery.

No one knows, even now, exactly what happens to turtle hatchlings from the moment they disappear into the sea until they turn back up off the same breeding beaches, sexually mature, several years later. Experts are forced to resort to talking about some turtle never-never land.

The movements even of adult turtles remain obscure. Tagging records show that females will return with remarkable fidelity to the same nesting sites, even though they may feed off perfectly good nesting beaches as much as two thousand kilometers away. It is hard to imagine any evolutionary pressure that could make such extreme behavior necessary or allow it to continue. And it remains impossible to account for the manner in which turtles manage to find such tiny specks of land as Ascension Island in the South Atlantic after very long voyages, usually against the currents, often in weather that conceals celestial cues, through areas where compasses become notoriously unreliable.

But it is good for us to be presented with such mysteries, to be reminded that brains a fraction of the complexity of ours are nevertheless capable of extraordinary refinement and can carry out feats of orientation and guidance using signposts we have yet to discover.

And there is more.

For a long time, two of the seven species of sea turtle remained so perversely elusive that they were believed either never to breed or to consist of just a single sex. It was only in 1947 that a huge enclave of over forty thousand ridley turtles were found mating and nesting together on a section of the Gulf Coast of Mexico.

Unfortunately, they no longer do that there. Since the discovery, that beach has been mined of both eggs and adults in such masses that one of the world's great natural wonders was destroyed before more than a handful of us got to see it.

But since then something wonderful has happened. In 1972, on the Pacific coast of Costa Rica, and in 1981, on the Indian Ocean shores of Bengal, even larger congregations of ridley turtles have turned up, in broad daylight, and made concerted assaults on beaches from which no such behavior has ever been reported.

It is almost as though the ocean holds secrets and succors resources of which we still know very little, and every so often it reaches out and probes the perimeters of our sphere of control, letting a little of its last bounty loose in ways that gauge our readiness to make a mature response.

So far, we have failed the test, exercising nothing but characteristic greed. But there may be hope in the fact that these recent overtures have involved the turtle.

It is hard to think of any other go-between, any ecological ambassador, more likely to attract our attention and to stir a little of the sort of sympathy necessary to demonstrate that, as a species, we are finally ready to take our place in the scheme of things. To recognize our responsibility for the well-being of the world. It is our turn.

It is time we took the load from the turtle's back.

Dr. Lyall Watson
July 1993
*Aboard the **Amazon***

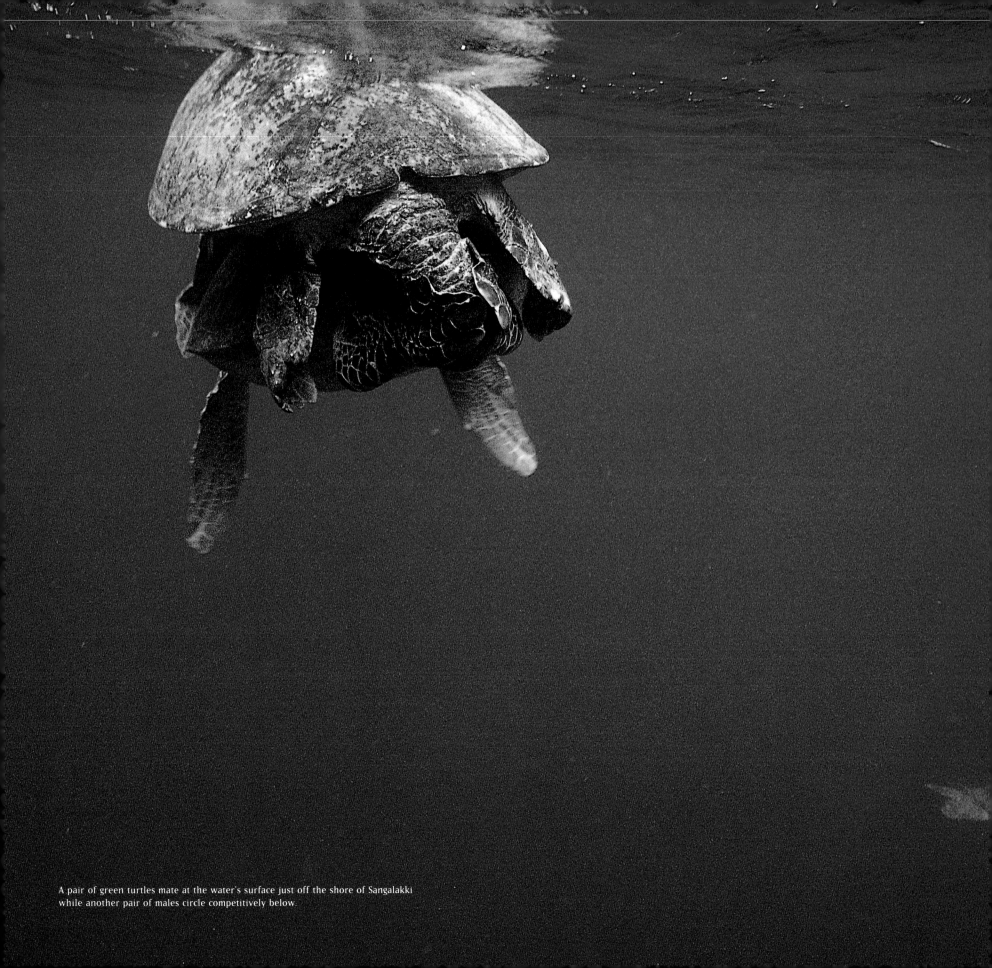

A pair of green turtles mate at the water's surface just off the shore of Sangalakki while another pair of males circle competitively below.

Introduction

Indonesia, the green turtle's prehistoric home, is now one of the most populous nations on earth, an archipelago of several thousand islands rimmed by endless beaches, both uninhabited and inhabited, black and white, stretching from the Indian Ocean to the Pacific. Bali is in the middle. The myriad festivals of the southern Balinese calendar require the sacrifice of green turtles, and with an expanding population, the mythical turtle is becoming more eternal than the living one. The earth changes and species disappear. The monitoring of the sea-turtle harvest is nearly impossible, and the time approaches when depletion will be beyond natural recovery.

The green turtles come ashore at night on a rising tide. Expelling deep cavernous gasps, emerging at the waterline, pausing, then crawling above the high-water mark to lay their eggs. It has been their way for millions of years, long before man appeared.

The old male turtle rests in a hollow twenty-five feet below the surface of a sheltered bay. His kind have evolved from the Triassic, living one hundred years or more. I lie on the bottom next to him, where we silently ponder each other's masks before rising to the surface for air. This setting draws a recollection of D.H. Lawrence: "Out of life's unfathomable dawn, far off, so far, like a madness, under the horizons dawning rim." Where has the she-turtle traveled during the last twenty to fifty years on her path to sexual maturity, I wonder? She is now of age, back at what may have been the site of her birth. Males glide in from the blue, seeking her. Sensing her sex, they compete, as many as six at a time vying to mate. Sometimes the males approach me. Large shapes in the water, they veer off at the last moment. The female is coy, hiding under a coral reef.

Once the male is on top, his large tail curled under, they mate for hours. I snorkel behind. They rise together for breaths, resting at the surface and on the bottom, as other males bite, trying to separate them. Mating is most active from dusk to early morning, especially from December through March. Eventually the turtles separate; the female may store the sperm for the following season. She carries hundreds of eggs at a time, to be laid in as many as ten trips up onto the beach over the course of two months.

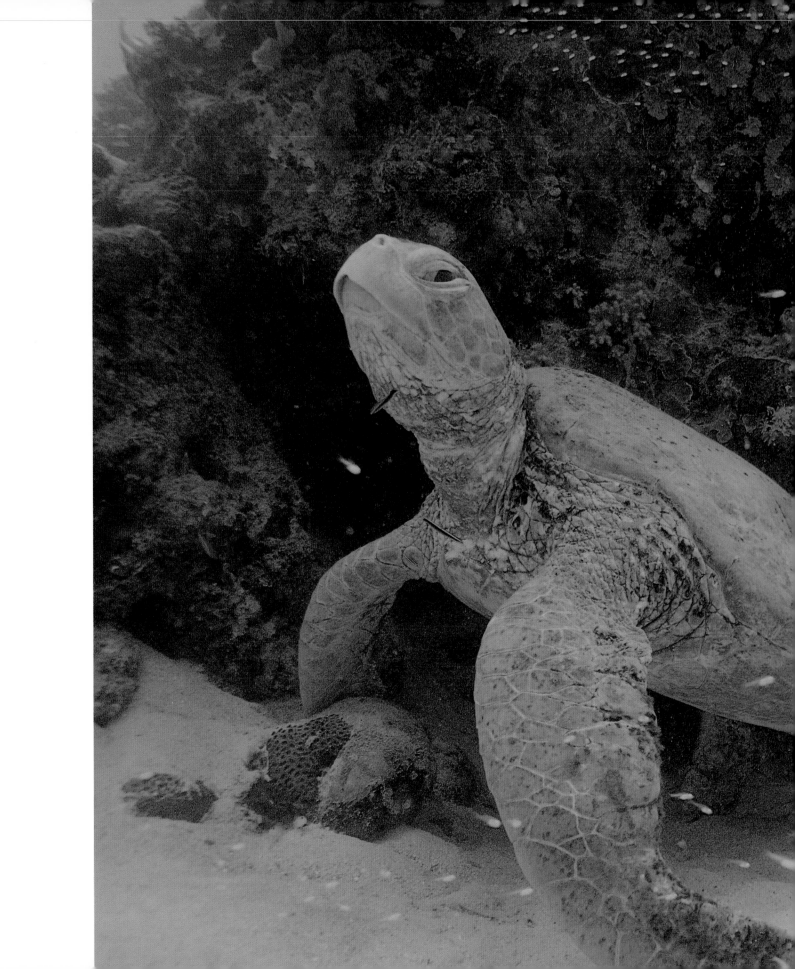

A large green turtle rests below a coral knob in about
twenty-five feet of water. He is perhaps seventy years old.
In a symbiotic exchange, he allows small fish to clean him.

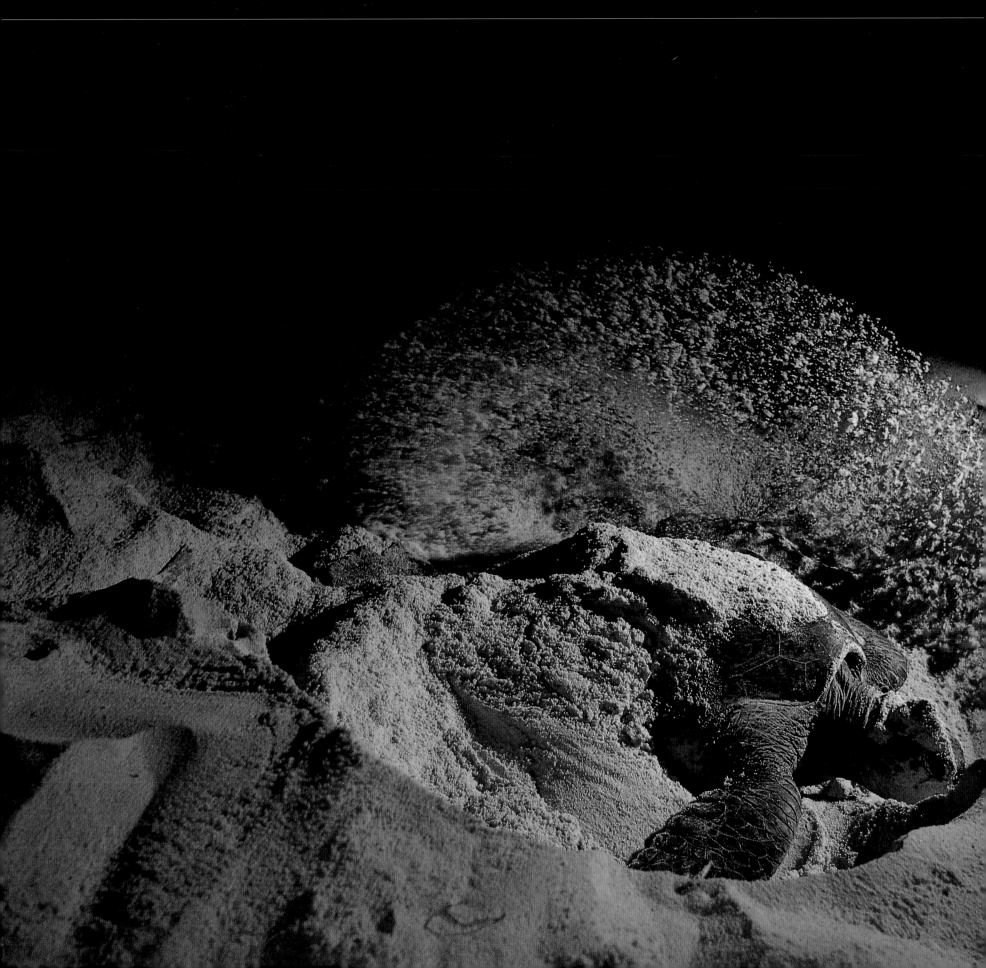

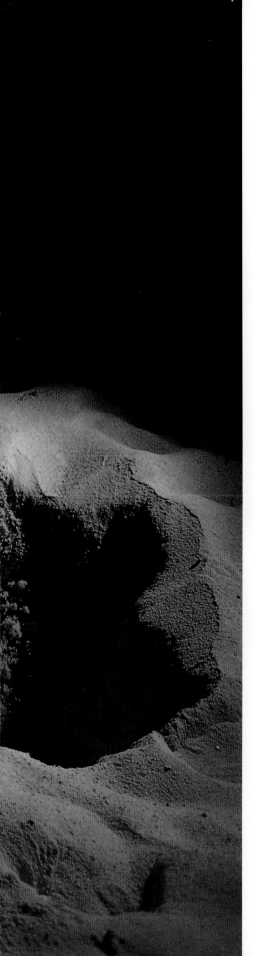

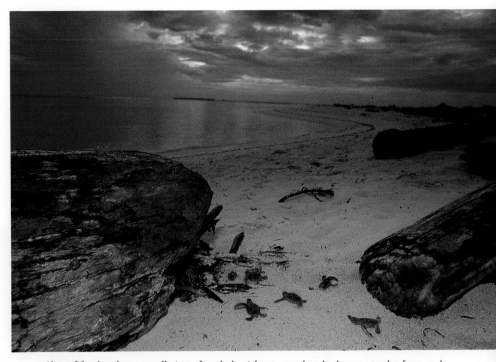

About fifty days later, usually just after dark, eighty to one hundred young turtles from each nest race to the sea past the ghost crabs and monitor lizards that prowl the beach.

A female green turtle sweeps sand to cover and protect her nest, after laying in the depression she has created above the high-tide mark on Sangalakki.

A twenty-minute time exposure with multiple flashes reveals the female's long course back to the sea. The tide has dropped dramatically since she came onto the beach.

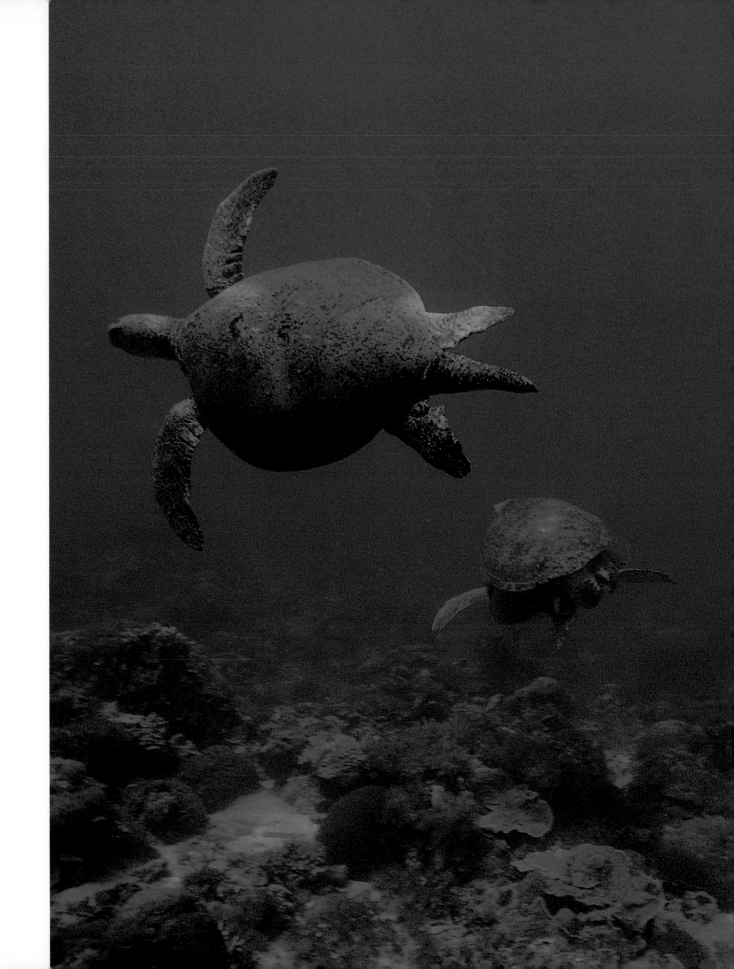

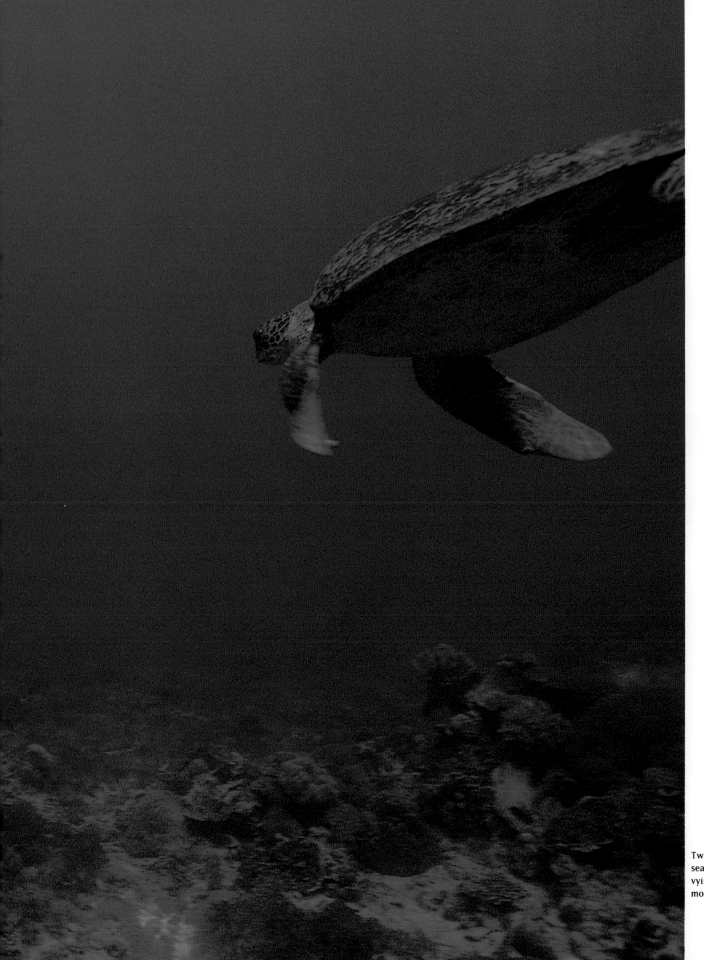

Two males challenge a fleeing pair. During the most active season this is a common occurrence, with up to eight males vying for one female, trying to displace the male already mounted on top.

29

Hunting

Most hunted turtles are sacrificed live to satisfy just one of Bali's myriad Hindu rituals.

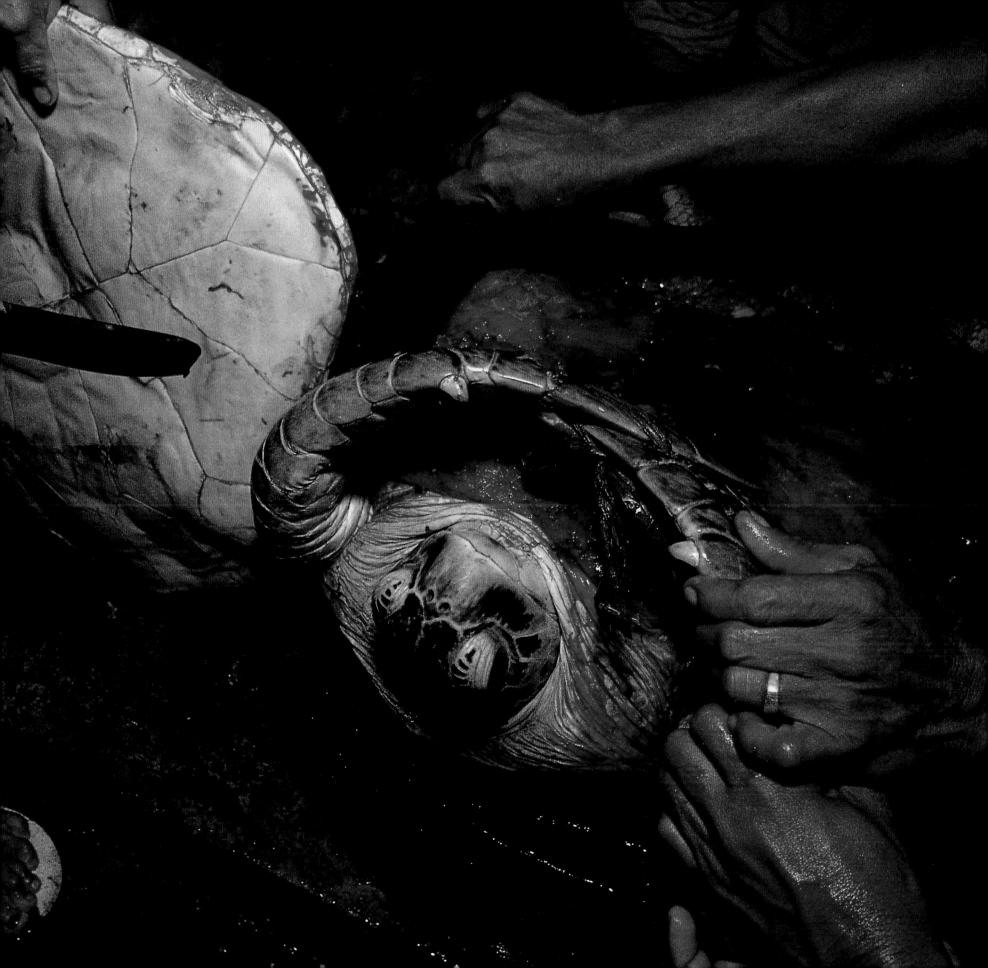

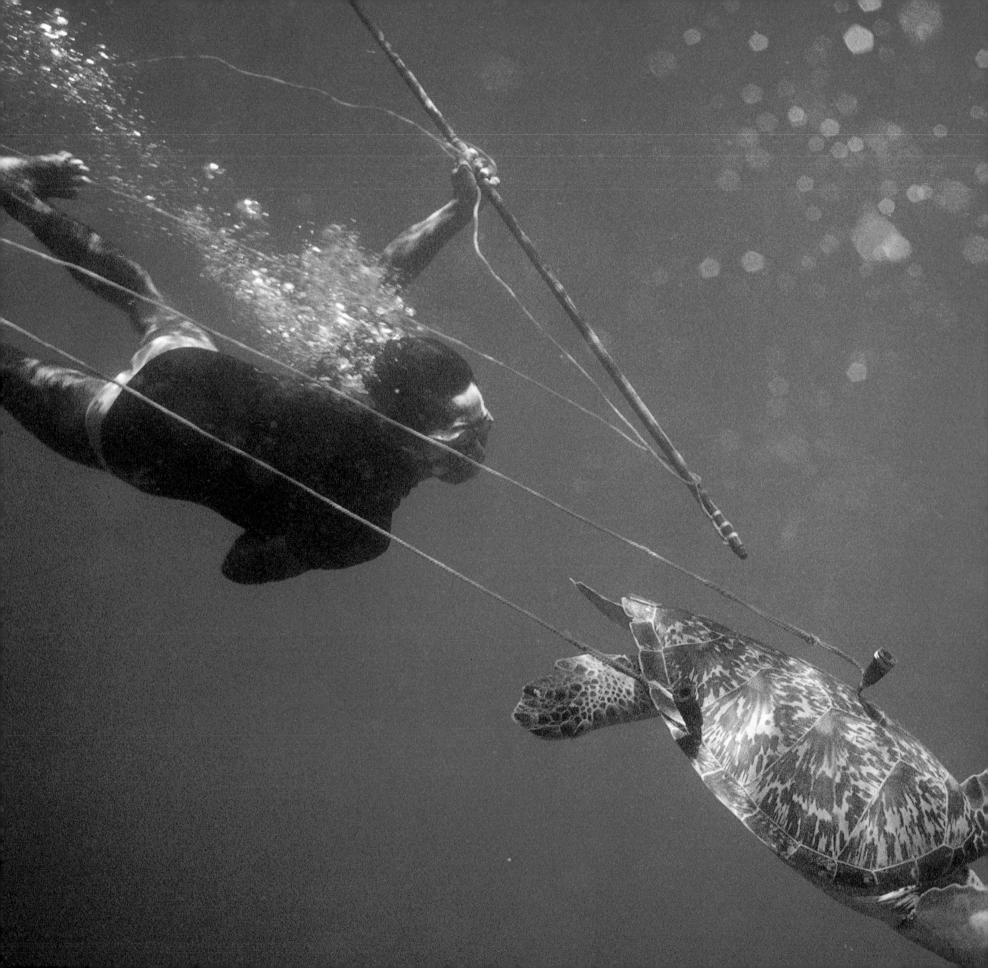

South of Sumbawa, a harpooned turtle flees the hunter. The harpoon tips do not injure the turtle's flesh, just securing the shell so that the turtle may be retrieved, to be sold alive in Bali.

Crossing the strait between Lombok and Sumbawa toward the turtling grounds, our boat pitches as I gaze blankly at the mute midday sky. The sail is up. It's the time between conversations and work, contemplating the natural order at a leisurely pace. Floating on the sea, all things seem to fit, to make sense. A high, hot sun controls the sky. Heavy clouds lie low to the south. Dolphins jump at the horizon. They flip backwards and the first mate, Jerem, exclaims, "Seventy-five dollars each in the market, delicious." He's an expert swimmer from Palue, near Flores, the brother of Anwar, the soft-spoken harpooner with whom I traveled a year ago. There's a young cook and two other deckhands on board, a total of five, plus myself. The boat is eight meters long.

Captain Marzuki and I are old friends. He is an honest, capable man with many friends among these islands. A constant vibration comes from the diesel engine, and Marzuki sits on the roof aft, guiding the rudder with a rope strung through the cabin. He says, "We'll follow the tides and weather, work when it's time, and not separate day from night."

Captain Marzuki and his Muslim crew on one of many small turtle boats
plying the waters of the Indonesian archipelago to supply the market in Bali.
A harpoon tip rests on the boat's registration papers.

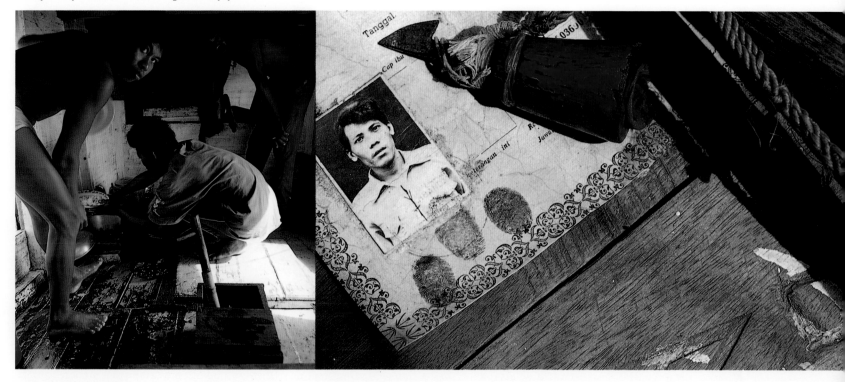

We return to Psing Beach, passing the dark cliffs and crescent bays on the southwestern tip of
Sumbawa. The beach stretches to the east, deserted, with jungle behind. It is protected by long waves
that maintain a well-defined edge before crashing. We go through a hole in the breakers to moor near
the beach, and as we do so the crew says that two Australian surfers scraped themselves badly on this
reef last year.

Waiting. The late-afternoon rain abates, and Jerem takes the canoe to set the turtle nets just beyond the
reef. They must be checked hourly so that any turtles caught don't drown. During large tides he positions
the nets inside the reef, checking them on foot when they fall with the tide.

Where currents abut, flotsam abounds from mangroves, bamboo, and coconut palms. There are also
instant-noodle wrappers, plastic bottles, and dead light bulbs. Dynamite fishermen pass by without
waving. The crew checks the nets. Small swells lift the boat. Marzuki shows me his official papers
stating that the annual limit for his vessel is two hundred turtles, and the governor's declaration that

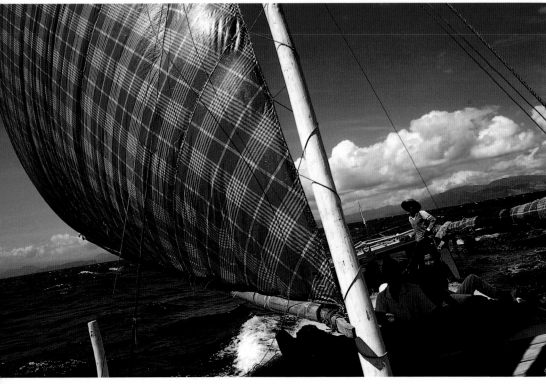

Crossing the Alas Strait between Lombok and Sumbawa, the sailboat uses both wind and diesel power.

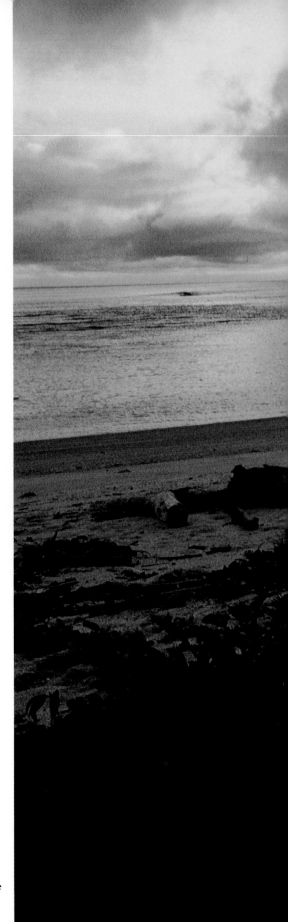

Morning on one of Sumbawa's southern beaches, where the turtle nets have been set.

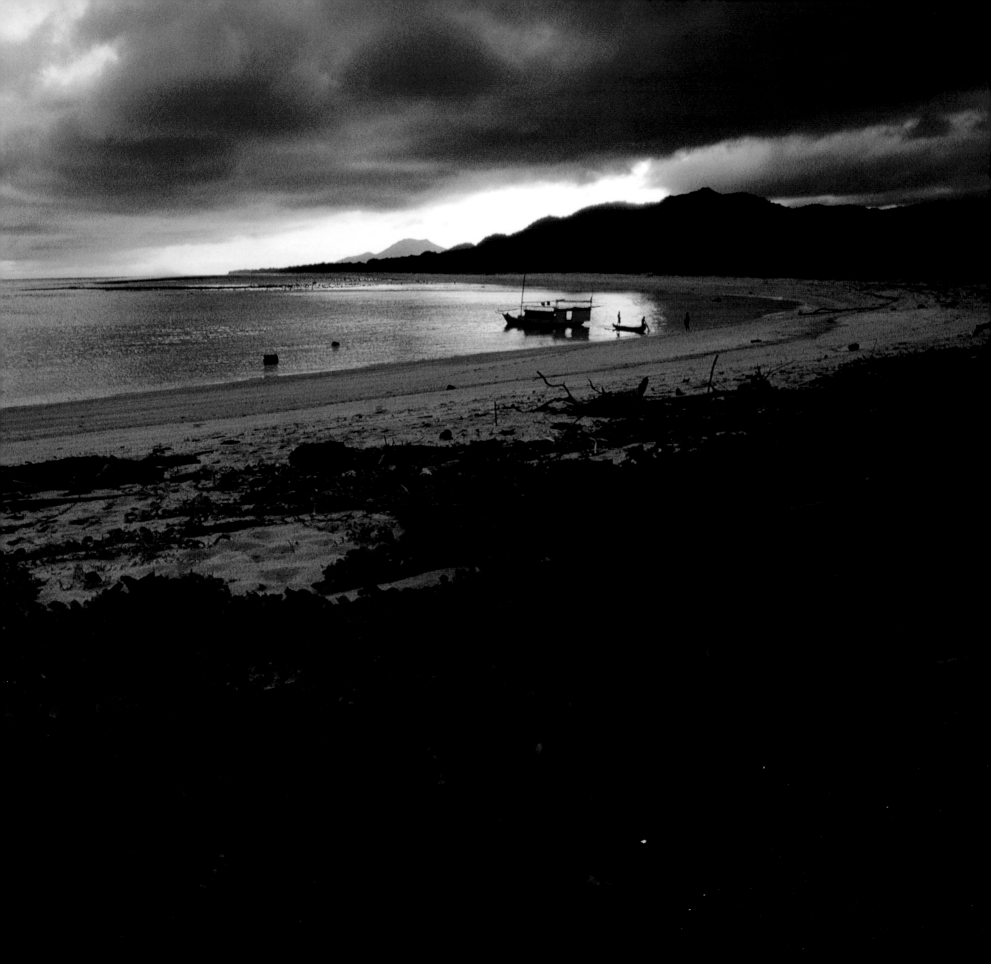

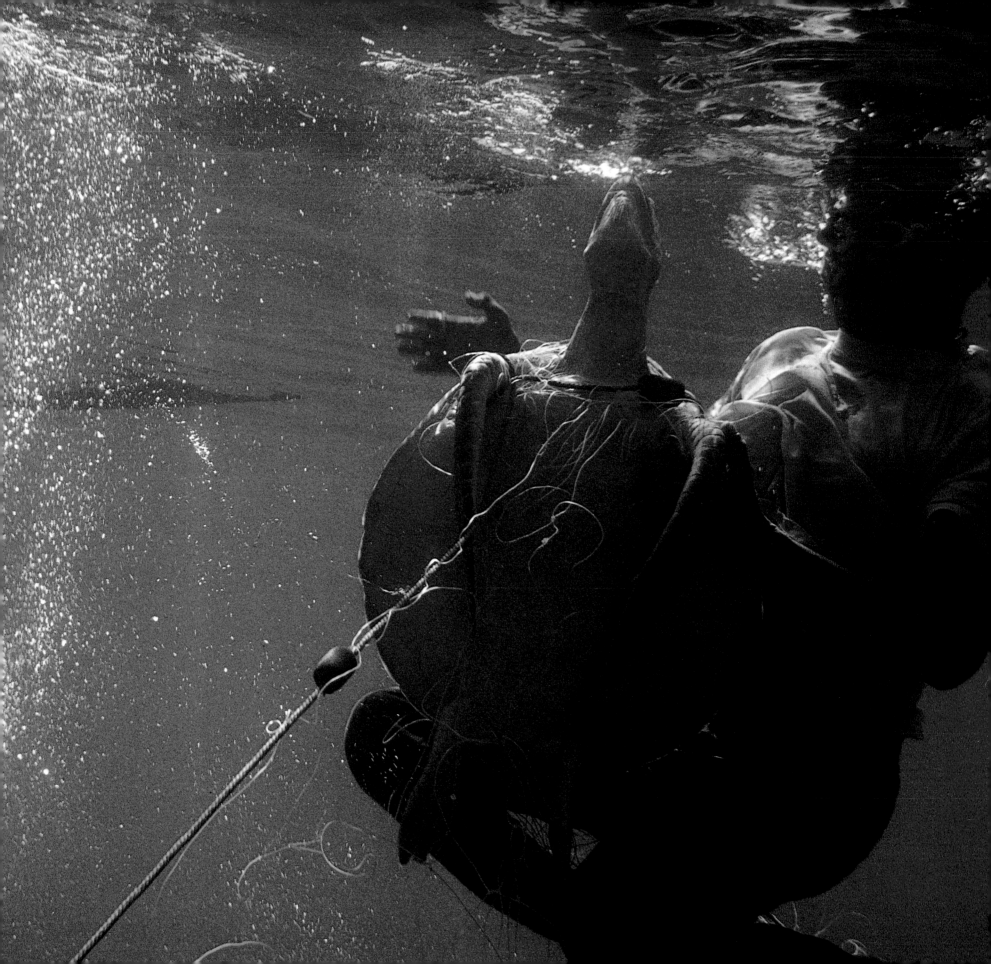

Left: Jerem lifts a young turtle to let it breathe. **Below:** A larger green turtle, also entangled by the net, sways in the current just above the reef. **Below right:** After checking the nets, the crew go by canoe to harpoon turtles from the surface or to dive after them. They take pride in their aquatic prowess, especially those from eastern Indonesia.

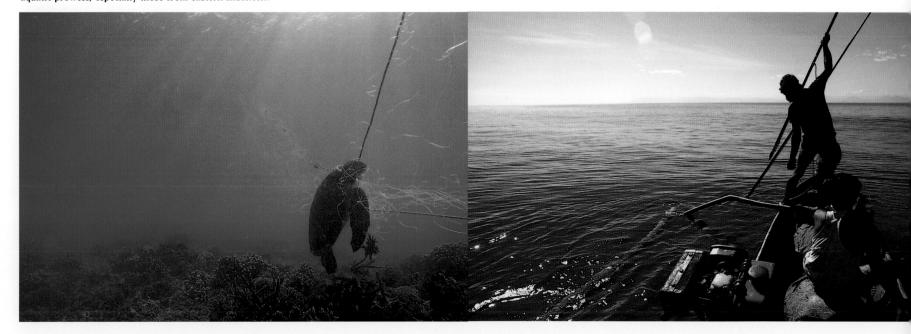

the yearly total for Bali is five thousand green turtles. This limit is completely unenforced, but reading the Indonesian reveals that it was imposed because of legitimate foreign concerns for Indonesia's best interest.

There are few turtles today, February 13. It is the second day of Nyali, the ancient animist rite that coincides with the annual hatching of sea worms at the waterline. All over this region work ceases for the collection of this delicacy. Usually deserted beaches are teeming with people at dawn, scaring off the turtles. The color of the worms—red, white, or blue—and their quantity signify cosmic omens. The people on the beach tell me it will be a poor rice harvest in the year to come—the worms are few and nearly black.

Night on the boat is a time for conversation. Between net checks and spicy meals of fried fish, I'm told that some hunters go into Australian waters to the south because the turtles are plentiful and it's closer than Irian Jaya. They say big turtles are easy to catch in the Aru Islands, but many die in the hold on the ten-day trip back to Bali, where they must be sold alive.

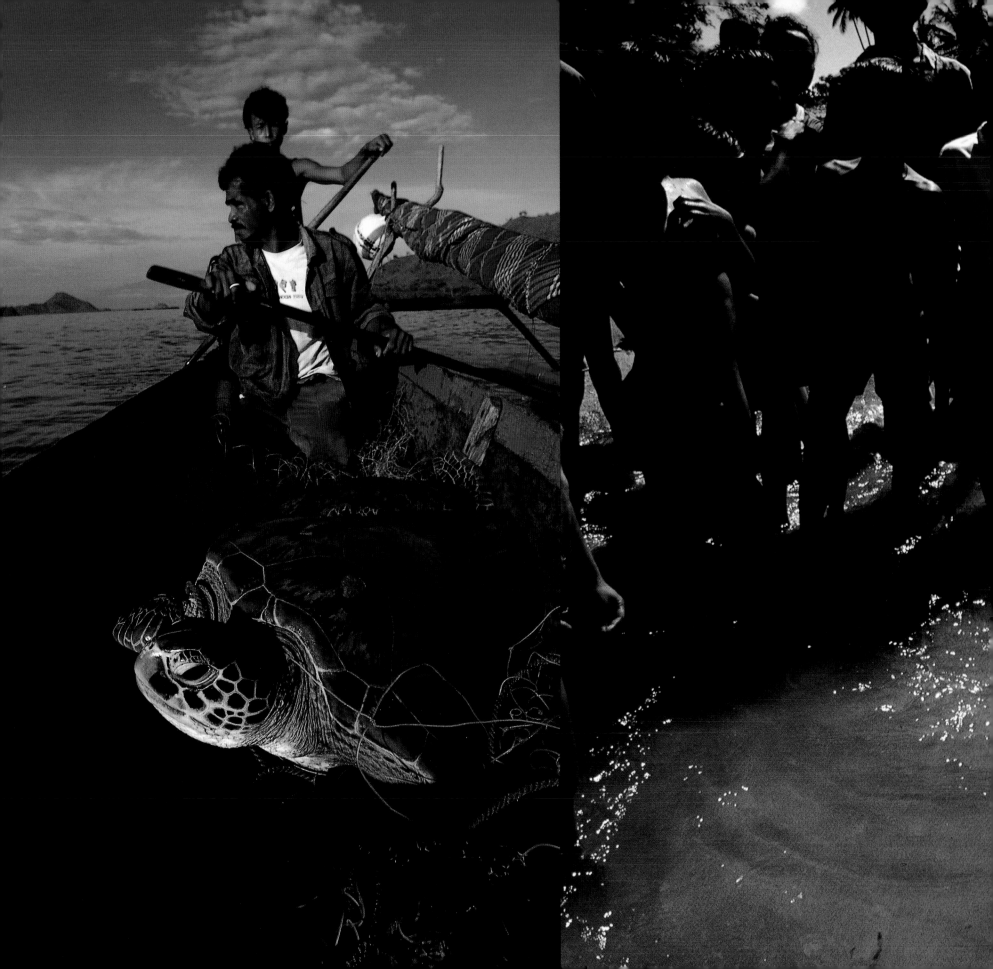

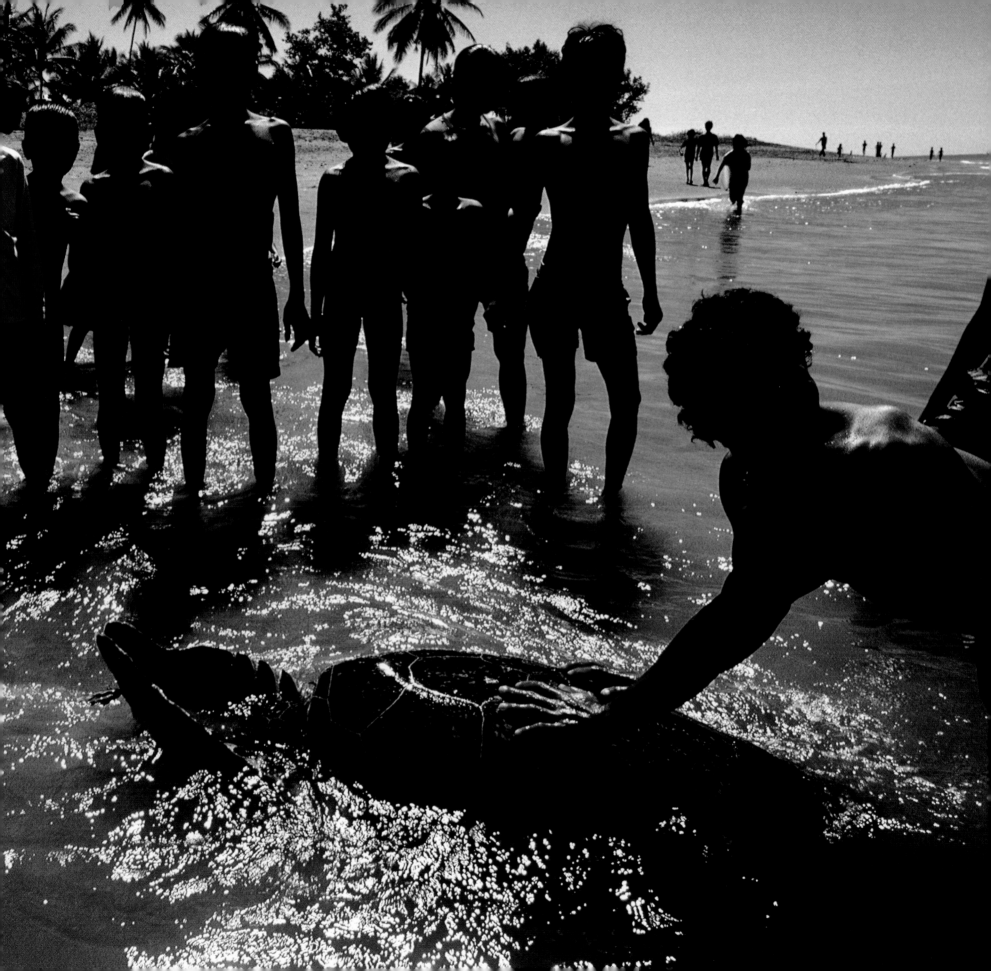

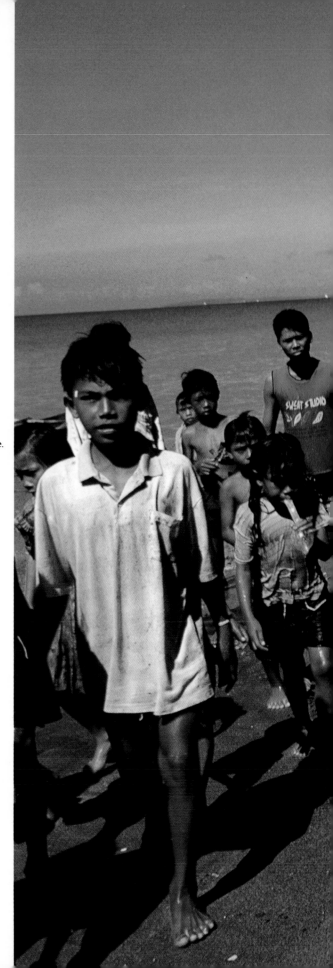

A turtle is carried and dragged up the beach toward the holding cage.

Two small turtles, a green and a hawksbill, are brought on board with a young manta ray. One boy says that a large green got away, tearing the net badly. Meanwhile, someone notices the harpoon tips are missing, and we borrow a pair from another boat nearby. They've just caught four turtles. We sleep on deck.

Harpooning accounts for the fewest turtles caught; most are netted. The sharp tip breaks through the shell and lies flat, so the turtle's flesh isn't torn. After impact, the point falls free of the shaft, and the harpooner retrieves the turtle with the connected rope. I photograph Jerem underwater when he goes harpooning or to untangle the nets, saving the turtles from drowning. The visibility is poor, and the net sways dangerously.

Turtles accumulate as the days go by, and we start to move them into bamboo cages built inside the mangrove tidal zone to the west. At the village nearby we trade fish for rice, roast corn, and squash. Usually the trip lasts ten days, but sometimes a month. There are bigger boats that hold three hundred turtles. They go as far as Tanimbar for two months or more. Fully loaded, this boat carries one hundred on the trip to Bali. Marzuki's boss has twelve boats. He is an Indonesian of Chinese extraction and has a good local reputation. Sometimes I feel like staying weeks, other times I want to jump ship. Marzuki and Jerem are great, but the three deckhands are typical teenagers; they require more patience.

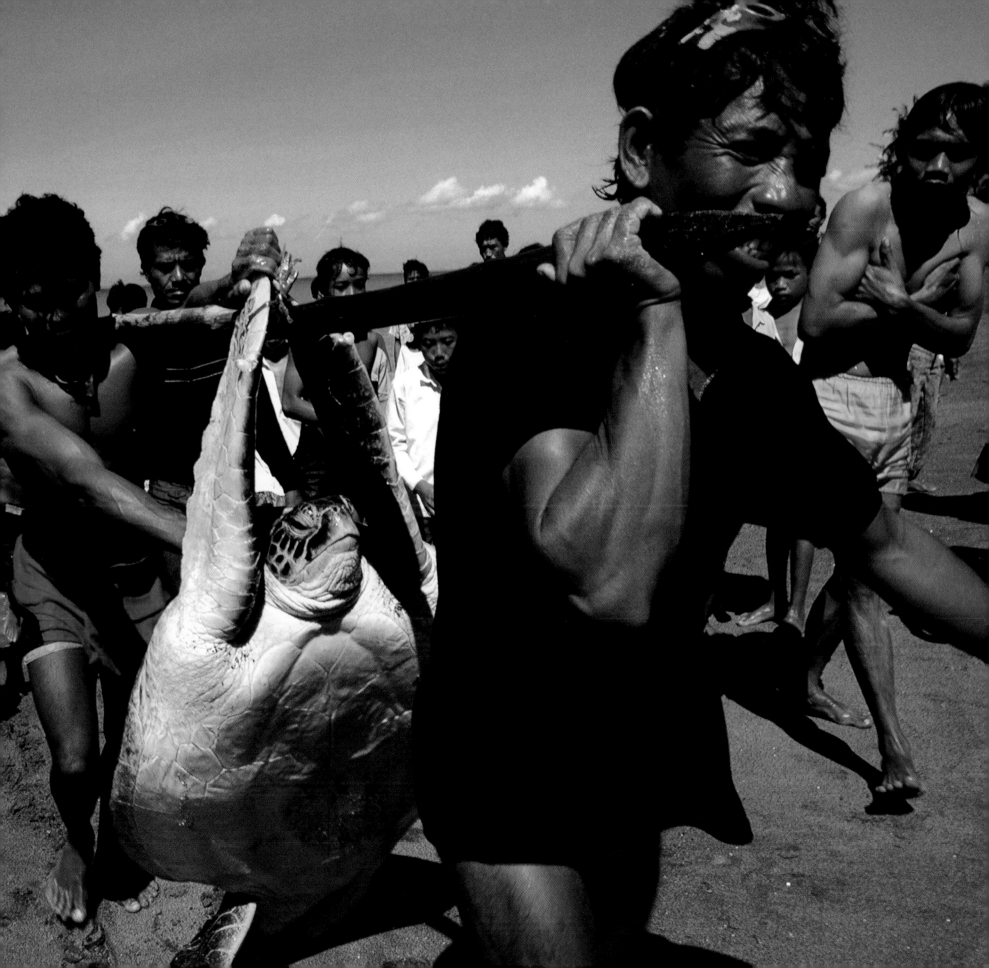

Merchants

Prior to an active festival period, the holding cages are full of live green turtles at Tanjung Benoa, southern Bali.

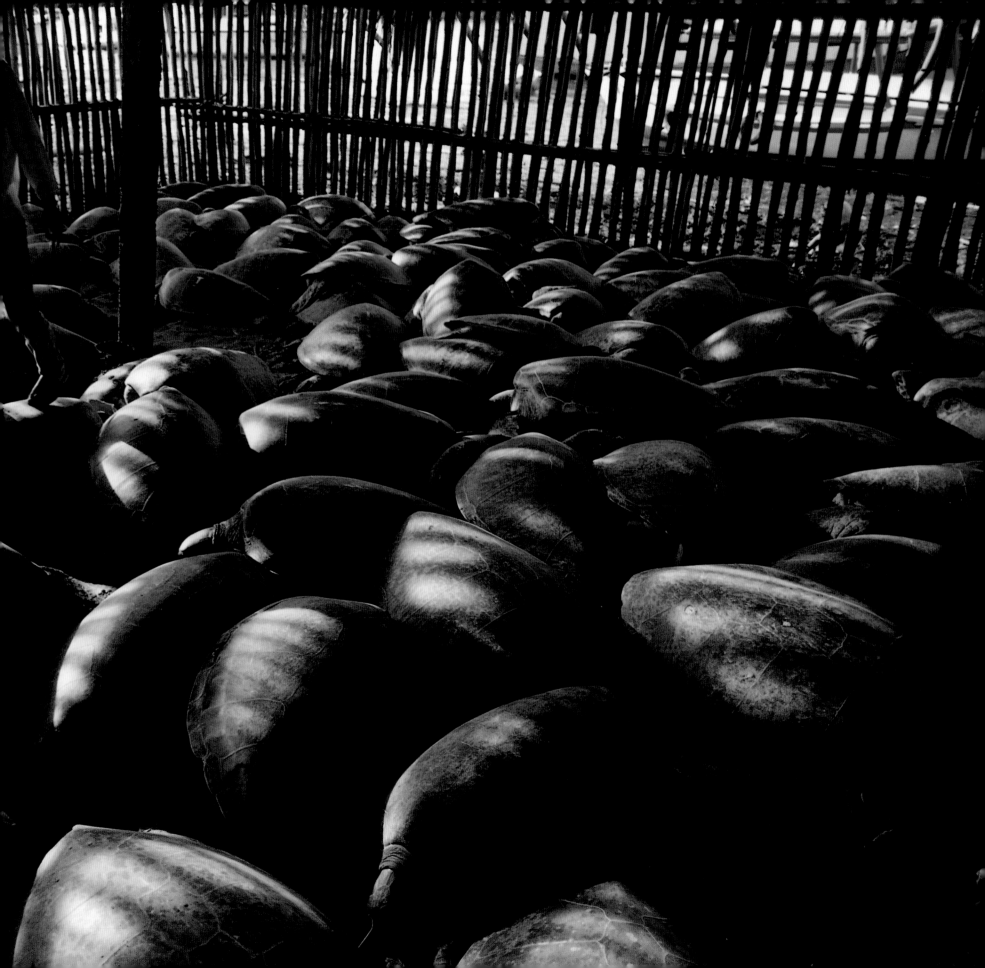

The turtles suffer under their weight in the cages and from the heat in the dry harbor during low tide. Young turtles perish easily and are removed from the cages and used as nonritualistic food. The average size of turtles caught has declined rapidly, an ominous warning for the merchants and for the future of the species.

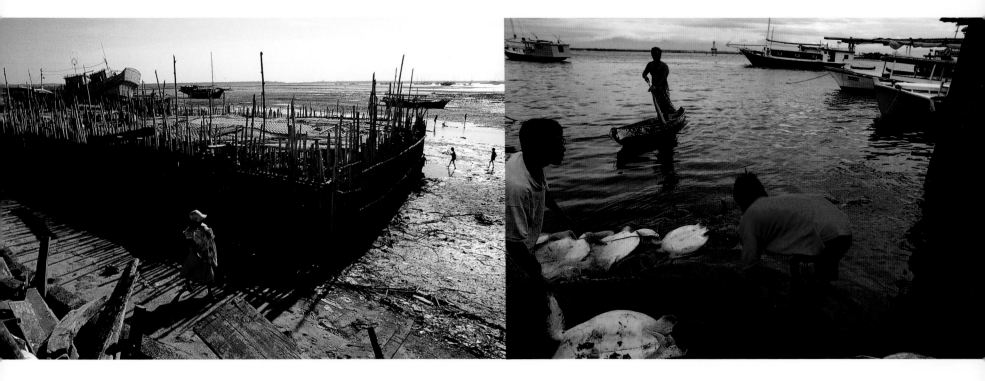

The turtle merchants are based in Tanjung Benoa, a southern port. In archaic, almost feudal business fashion, they outfit crews of hunters with boats and gear, dispatching them to the far reaches of the Indonesian archipelago. The hunters are poor fishermen, mixed crews from Sulaweisi, the Moluccas, Lombok, Sumbawa, Flores, Timor, Tanimbar, and Irian Jaya.

By advance promise or telegram, the merchants arrange for the turtle deliveries to precede the important festive days of the Hindu calendar. On the fishermen's return, the merchants tally the living turtles, and the purchase price is balanced against the fishermen's debt for using the boat. Their net income is meager, though the value of their cargo high. They must venture farther from home as the turtle populations diminish. The farther they go, the more turtles die en route. In fact, as many as 50 percent die coming from Irian Jaya, ten days' travel from the east.

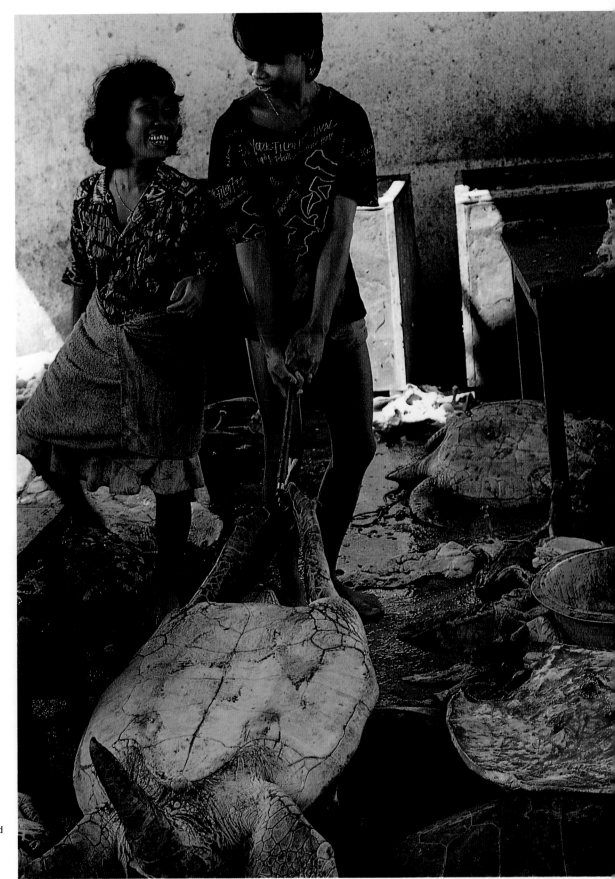

A male green turtle is dragged across the floor to be butchered and sold in small amounts to restaurants, or for rituals where a whole turtle is not affordable.

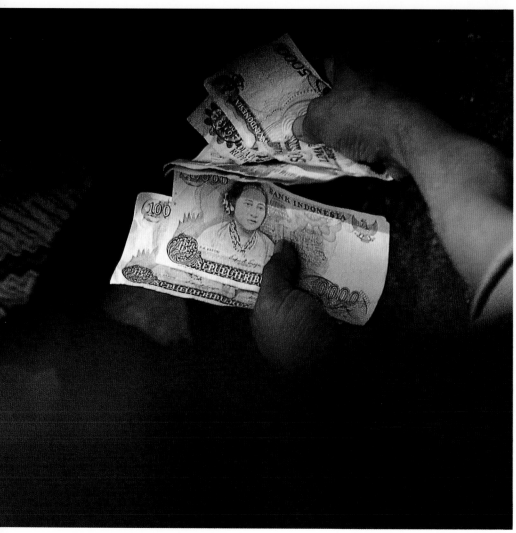

Indonesian rupiah are exchanged for the turtle,
which is being carried to the slaughter.

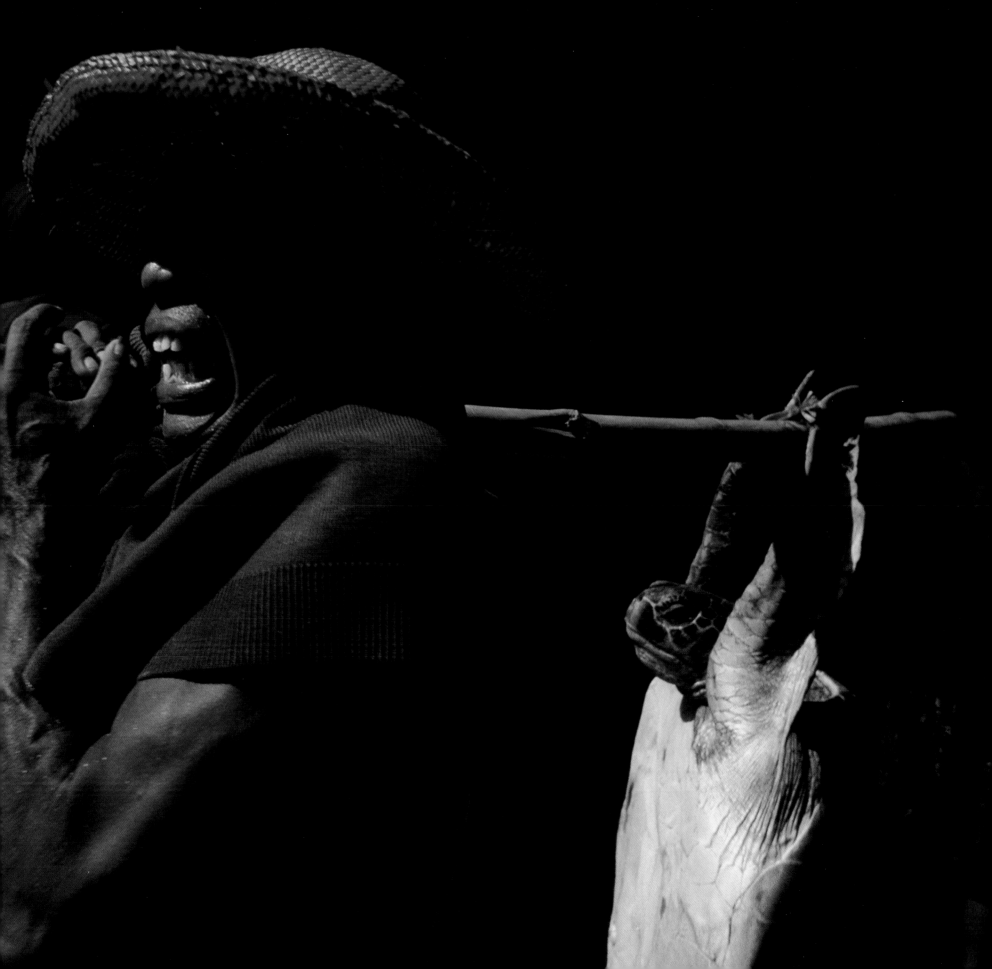

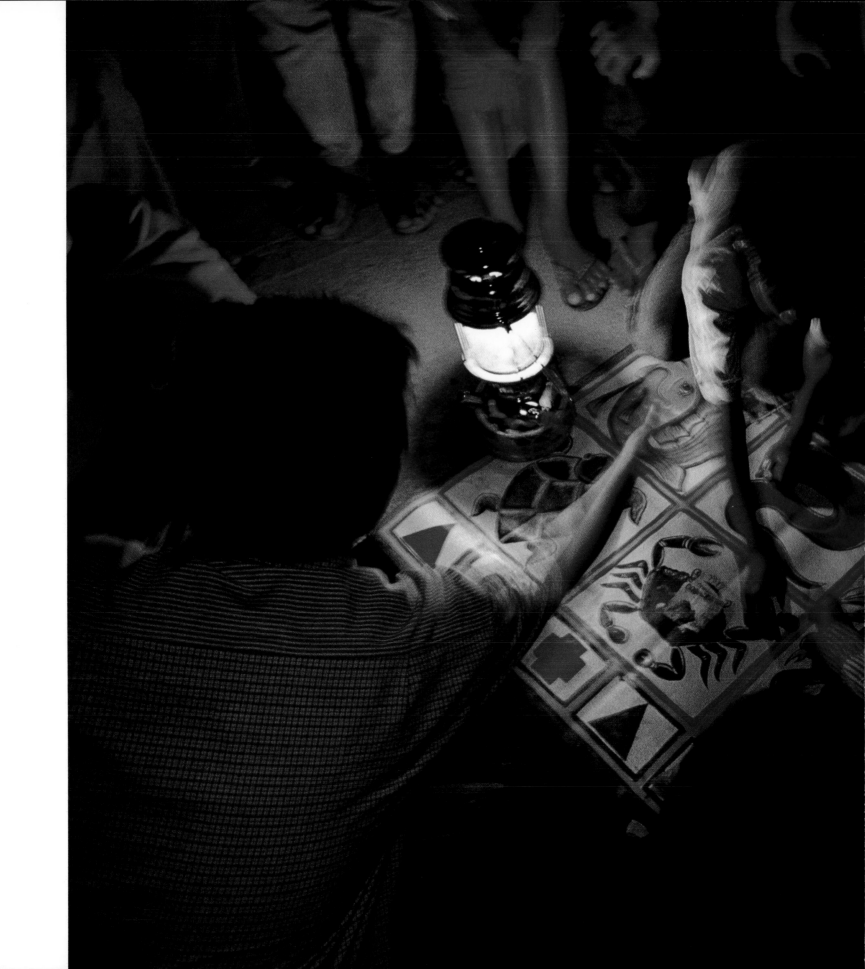

At night near Tanjung Benoa's Chinese temple, players gamble on a dice game, betting on symbols from the sea. *Clockwise from upper left:* Elephant fish, eel, shrimp, dragon, crab, and the turtle.

In the holding cages, a large turtle raises his head to inhale while swimming during the high tide.

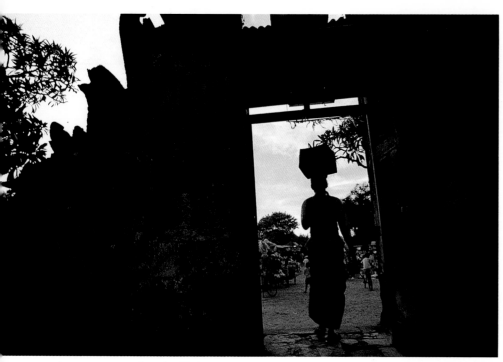

A woman stops at the gate of Dalam Tanjung temple, opening onto the square at Tanjung Benoa, a historic port.

Daybreak in Bali. A new boat has appeared near the bamboo cages that hold the live turtles. It has already been unloaded. I ask where they've come from and how many turtles they delivered. The answer is cautious but friendly. They know the Western world is watching. Besides protecting their livelihood, they don't focus on or consider the cumulative effect of their hunting. Truly, they can't afford to plan for tomorrow. Turtles have been hunted since man came to these waters, and change has always been slow here.

Live turtles are caged by size just behind the merchants' quarters. With high tide, they swim in the shifting film of sewage and petrol. By low tide they smother under their weight, lying on the sand gasping as they are checked over by prospective buyers. The large ones survive almost indefinitely this way, while at nearby food stalls the small turtles that perish quickly are butchered.

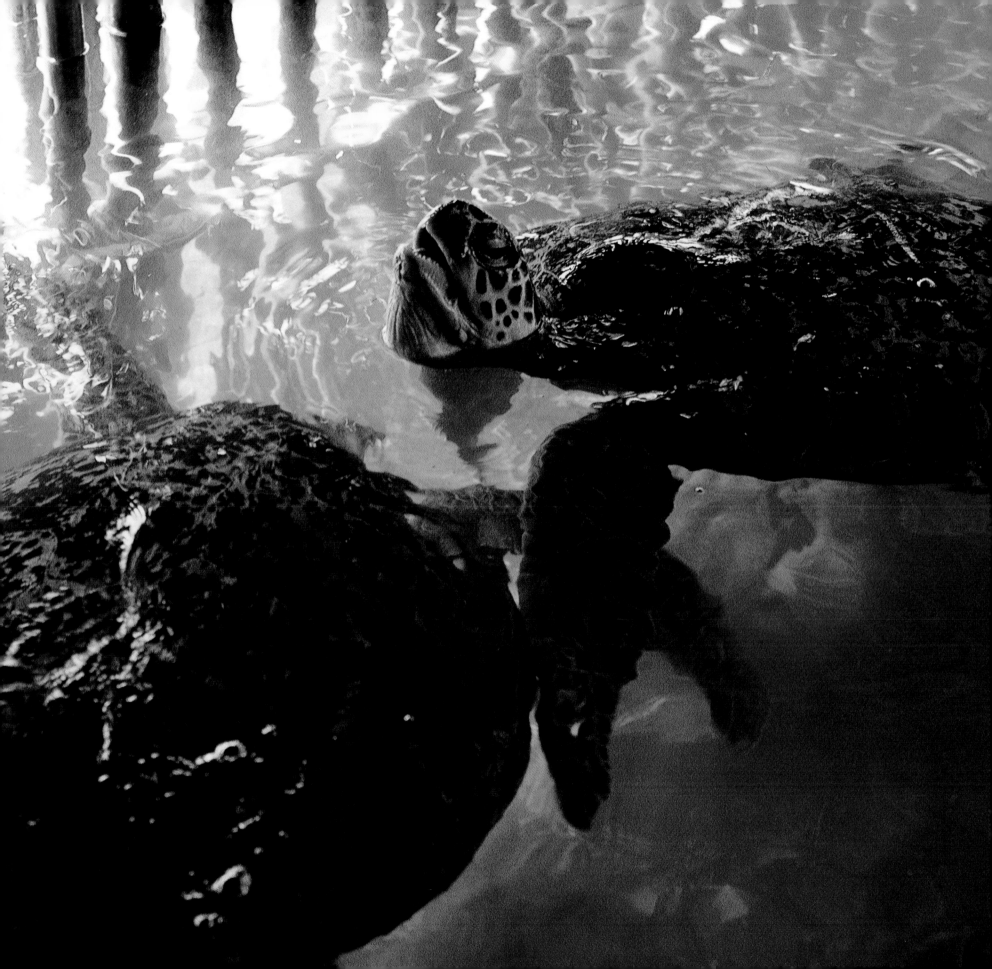

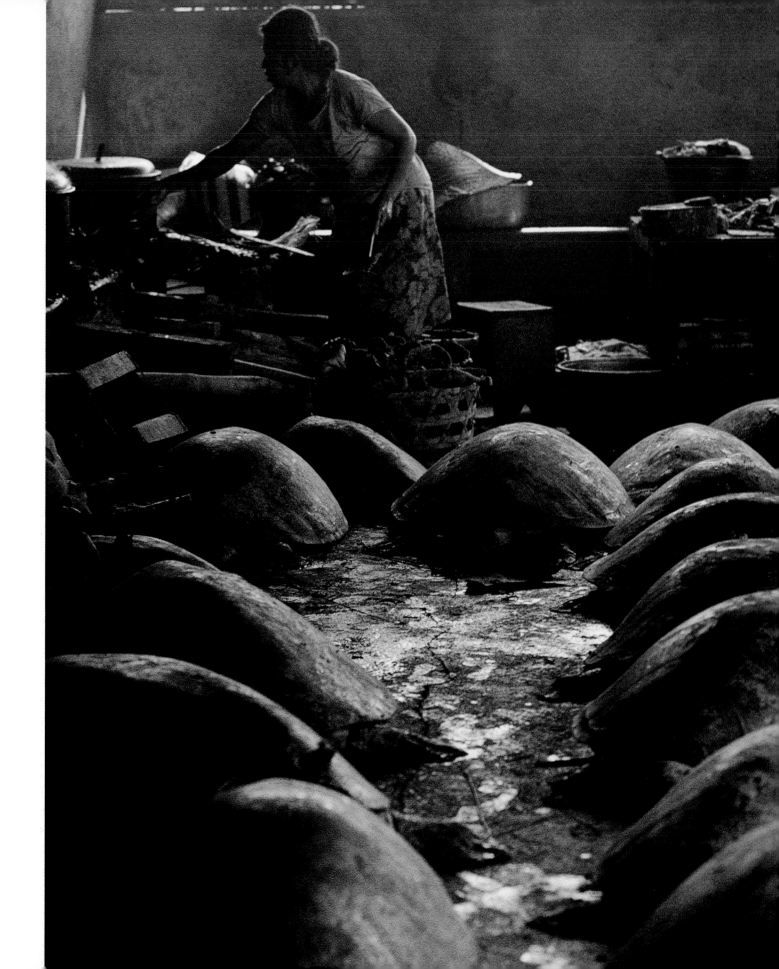

Turtles await their fate in line for the cooking pot in one of Tanjung Benoa's merchants' quarters.

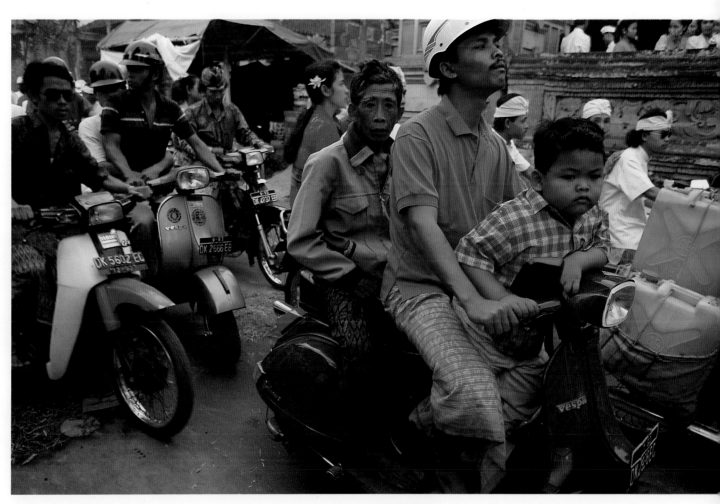

West of Denpasar, festival crowds and passersby create congestion on the village roads, taking heed of the coming procession.

Low tide in the bamboo cages where the turtles wait to be sold.

Marzuki's boat is repaired and stocked with supplies in Bali before he returns home to his family on Lombok and then to the beaches of Sumbawa to continue hunting turtles.

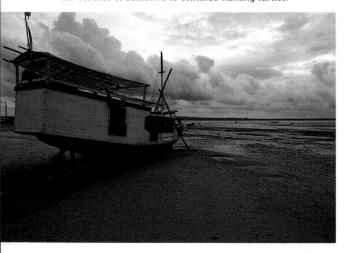

Taiwanese vacationers straddle a long rubber "banana boat" and are towed through the harbor. They are then led to a "turtle conservation center" to take pictures of each other sitting on large greens, passing by these cages as though blind to all but the conjured brochure images that lured them to Bali in the first place. Bali is still an incredible place. Local belief has adopted to the modern but retains many of the ancient ways. The Balinese still refer to turtles with a separate language reserved for the unclean, animal realm.

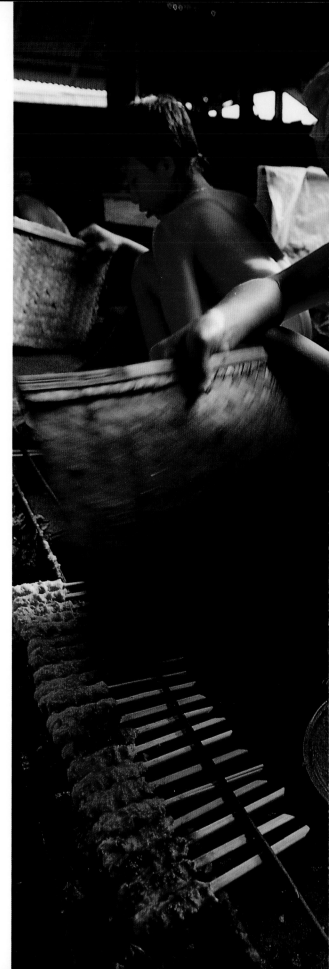

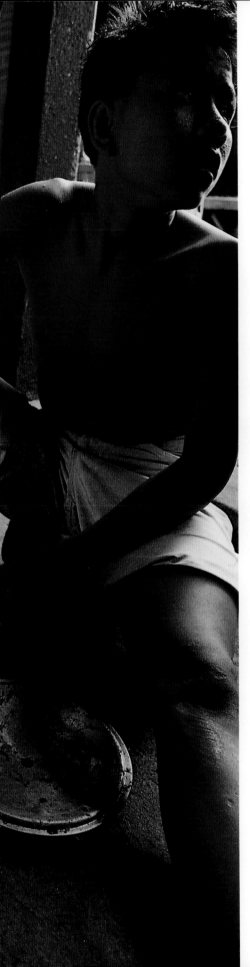

Balinese satay is prepared from the minced meat of small turtles
and is available at restaurants in front of the turtle merchants.

Each morning I rise early and begin the day hanging around the turtle merchants. They serve spicy
turtle, prepared several ways, with rice. It is colored green by the fat for which the green turtle is
named. I've learned to read the standard Balinese-Hindu calendar and now know when the auspicious
festive days occur, thus predicting the days when the turtles will be purchased.

Village representatives and middlemen begin to arrive to arrange these deals, buying for upcoming
festivals, usually two days in advance. A chalkboard in the back records the sales. I ask about the
nature of the festivals and for permission to attend. The turtles will be loaded the following afternoon.
In the meantime I'll prepare my cameras and wait.

Ritual

A girl passes by her household family shrine. The base is the turtle Bedawang, held down symbolically by two dragons.

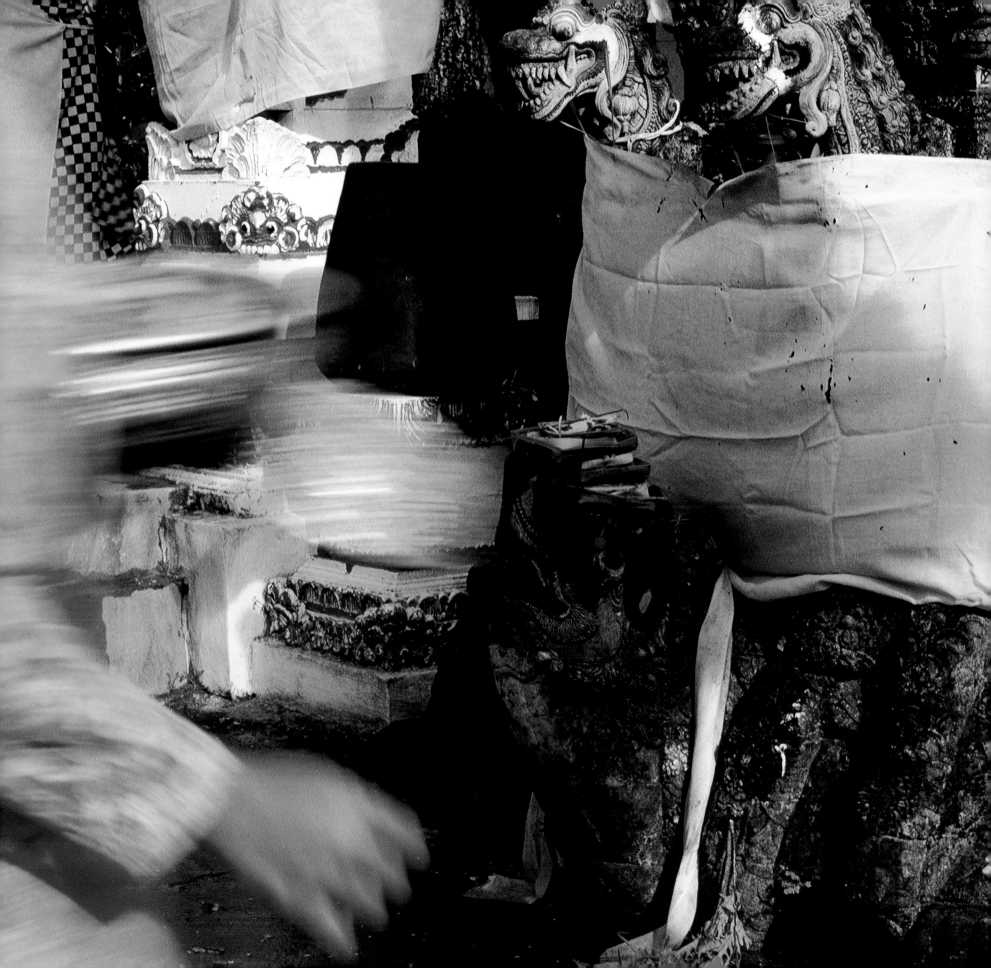

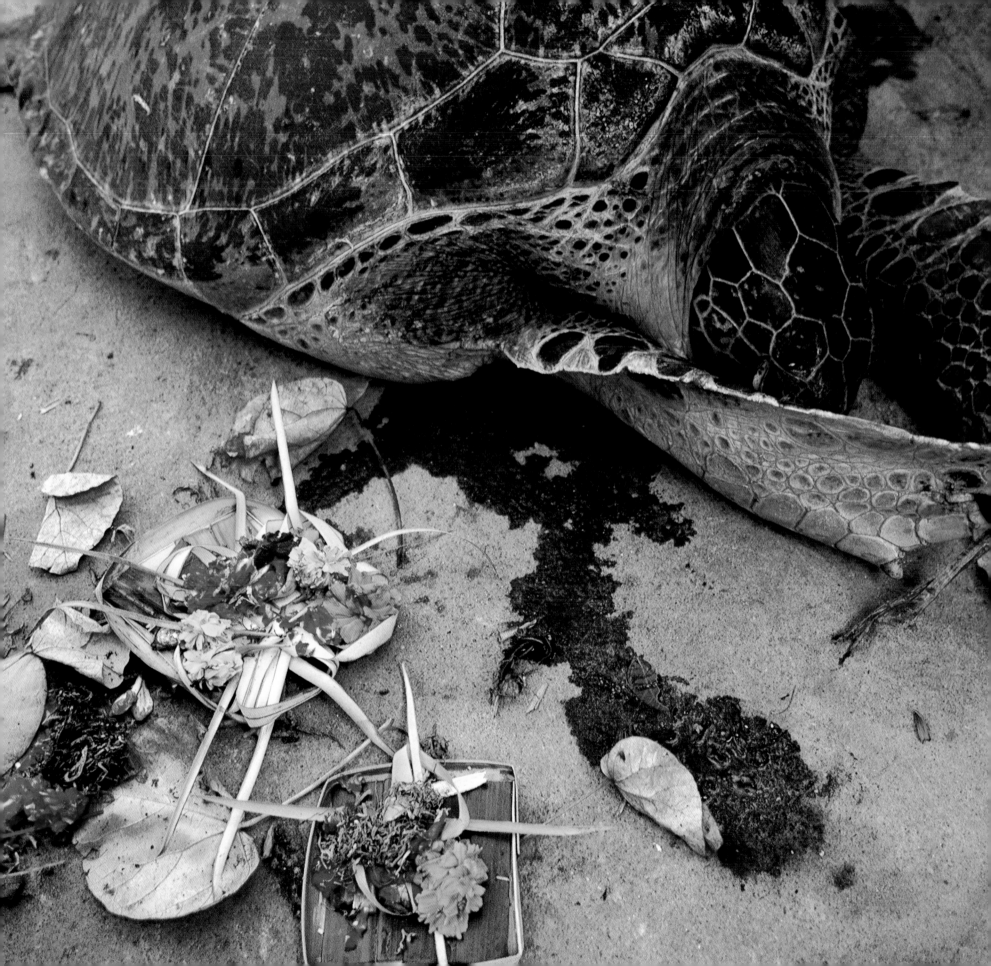

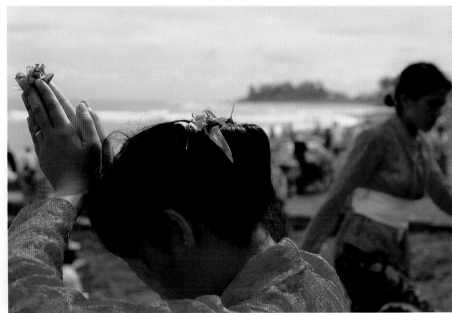

Prayers on the beach at Lebih for Nangluk Merana, a festival intended to keep calamity at bay.

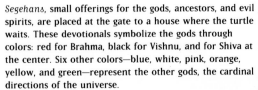

Segehans, small offerings for the gods, ancestors, and evil spirits, are placed at the gate to a house where the turtle waits. These devotionals symbolize the gods through colors: red for Brahma, black for Vishnu, and for Shiva at the center. Six other colors—blue, white, pink, orange, yellow, and green—represent the other gods, the cardinal directions of the universe.

Driving behind, I follow the middleman's Chevy pickup through the traffic and confusion of Denpasar, Bali's capital city. We pass resort signs on the road to the countryside. This is one of Indonesia's most prosperous areas, with satellite dishes on many rooftops, delivering CNN and MTV. As I follow, turtle urine drips from the truck's bed onto the hot asphalt—a primitive cargo traveling at high speed in the midst of a developing infrastructure.

Asking directions, we head down a dirt road into a small, well-kept village. We stop at the Banjar, the community's administrative center and meeting place. The driver introduces me and says I'd like to stay and photograph the festival. Invariably, the response is one of welcome. No tourists come here. My host is concerned about where I'll stay without a hotel nearby and is pleased when I say that since he won't be sleeping this evening, neither will I. Balinese are supremely hospitable and love to share their festivities. The crowd is receptive, giving me coffee and showing me around. They are proud to have a foreigner attend.

63

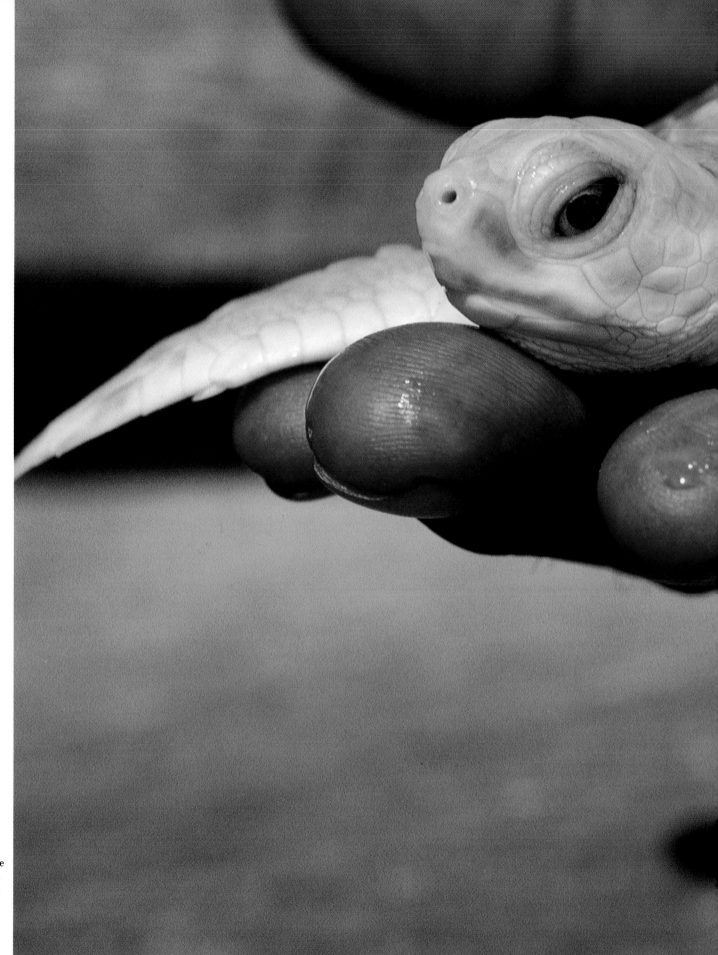

An extremely rare albino green turtle, found on the beach in east Kalimantan, is kept by the locals as a curiosity. They do not realize its high value in Bali.

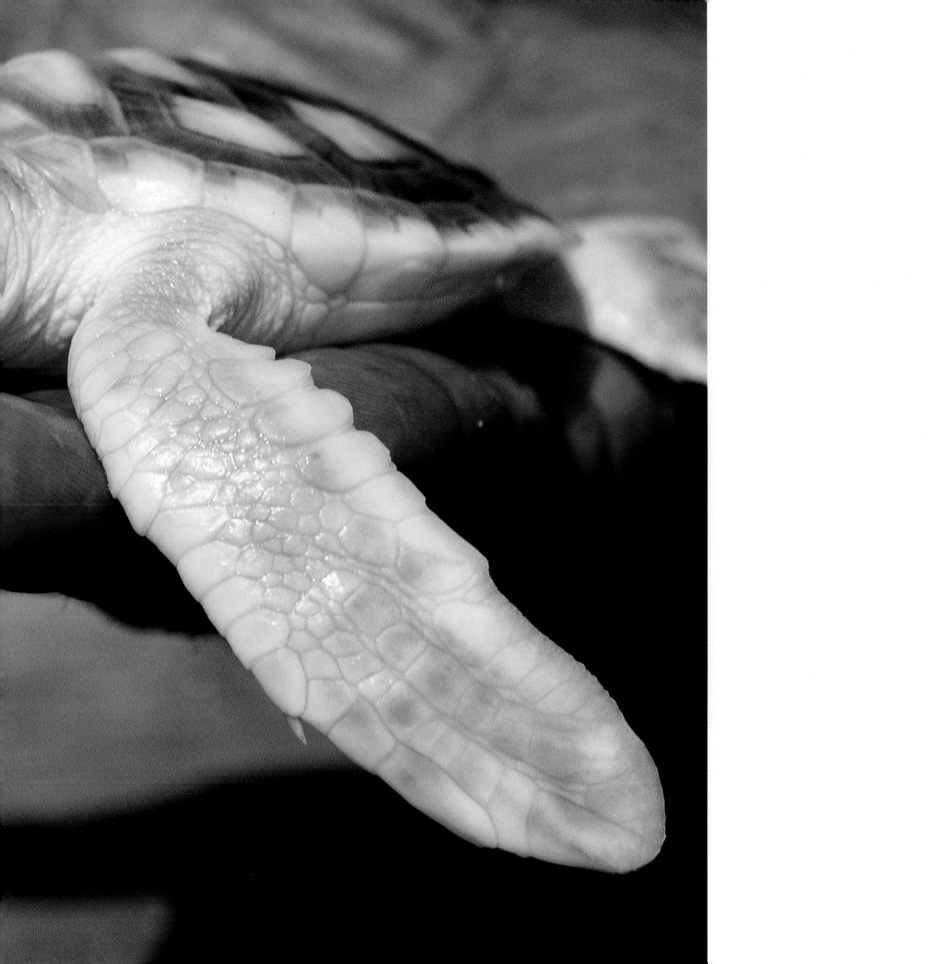

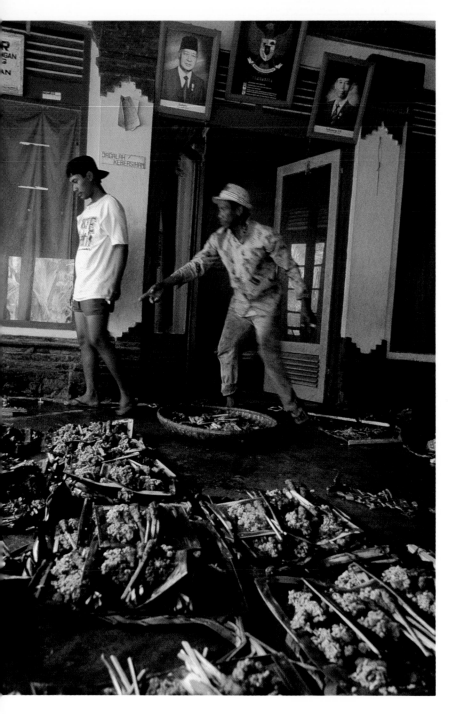

After being cooked all night, the turtle is served in many ways for the village's shared celebration at Kerobokan, near Kuta. The occasion marks the three-month coming of age for thirteen children.

Turtle organs are lifted from the cauldron during the all-night preparation.

Three large turtles are unloaded from the truck. In a symbolic welcoming, the shells are marked with white crosses. This is a major purchase for the community; the host passes 550,000 rupiah (about $275) to the driver. He bids me luck and drives away.

Turtles are slaughtered in southern Bali for Manusa Yadnya—the core human rituals. These rites of passage occur when a child reaches three months, for teeth filing—a coming of age—for marriage, and after death, during Nyika, when the ashes of cremation are dispersed.

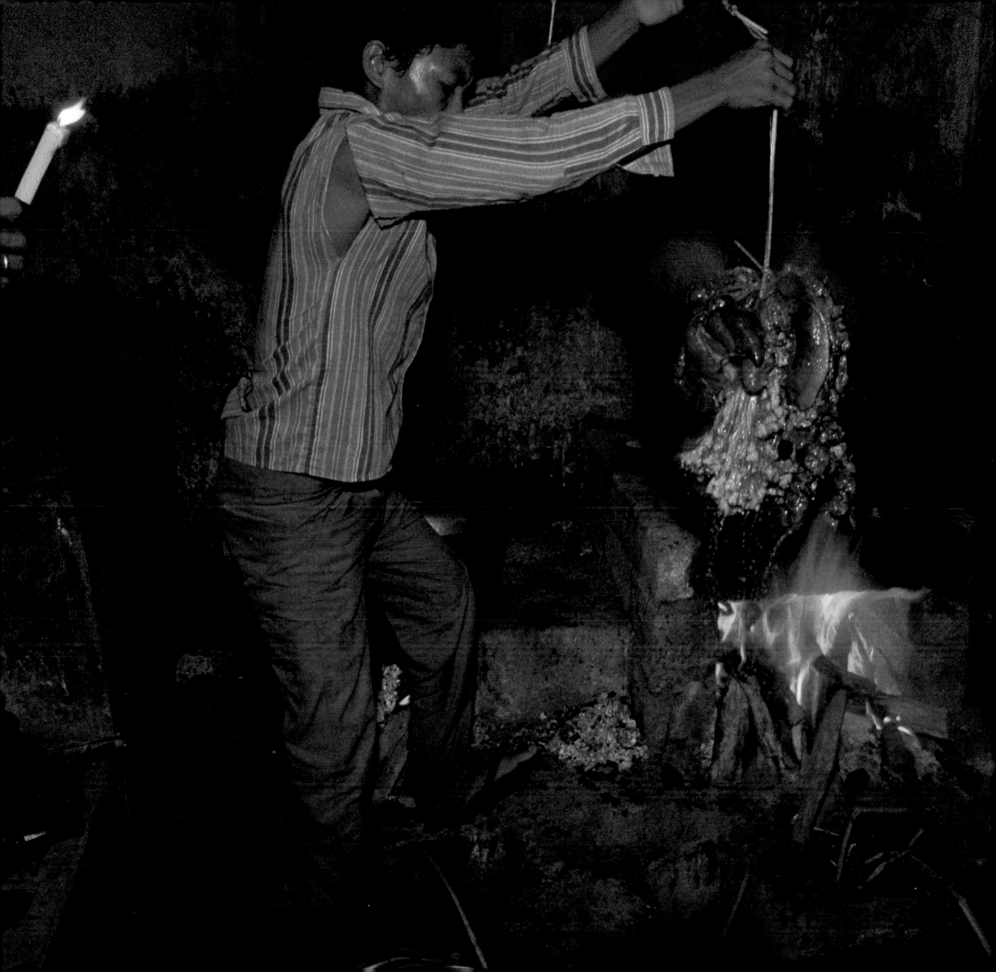

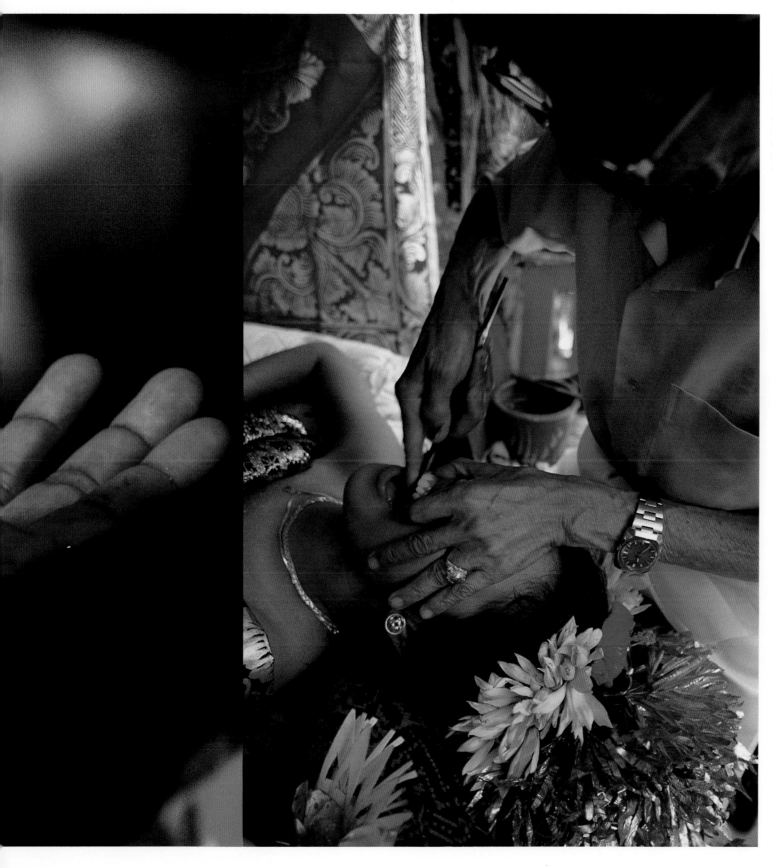

Masangih, a ritual tooth filing and coming of age in the village of Dadakan, near Denpasar. This rite symbolically refines the animal nature in humans by filing flat the canine teeth. Ten individuals take part, though sometimes more than forty will share this mandatory purification.

During Nangluk Merana at Lebih, families collect *tirtha*, holy water that signifies a request for the ancestors to protect and care for them.

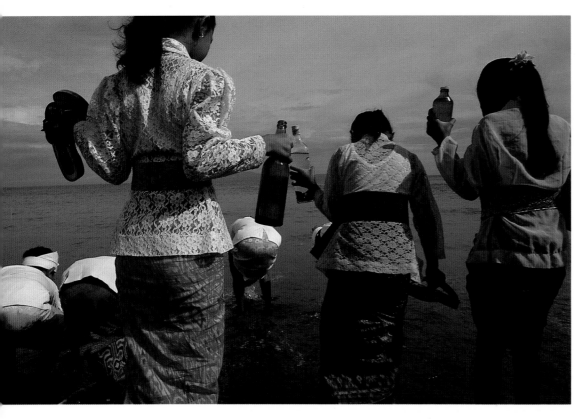

Mass turtle slaughter seems an ancient custom in Bali. In fact it is not. The practice has developed over the last one hundred years. Turtle meat has become a luxury item to honor guests with, and their decimation is a modern problem, accelerated by a growing population.

Prayers are being held by the sea for thirteen children who have recently reached one hundred and five days of age. I watch as women carrying banten on their heads take the tall offerings to the host's house. These families have arranged to share the rituals and the costs of the celebration through the community's Banjar.

At night, before the main festival day, thirty men are gathered at the Banjar, discussing local issues and socializing. The turtles are laid upside down on a raised platform under fluorescent lights. Without killing them first, two men cut at the margin of the yellow underside. The turtle's head retracts, he seems to have accepted his fate. A cavernous gasp. He sheds silent tears, with his flippers tied together

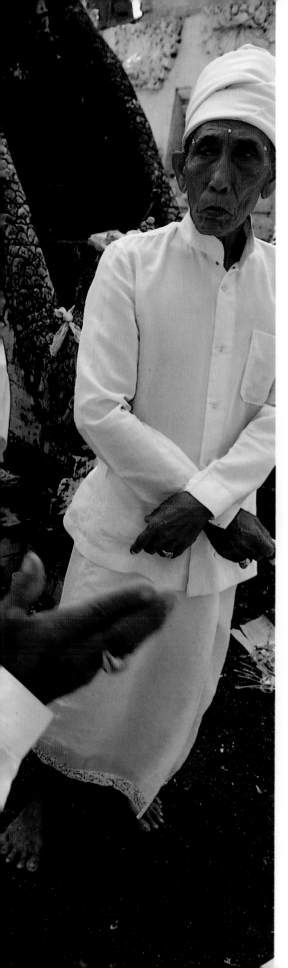

The priests (*pedanda*) at Tanjung Benoa's Pura Dalam
Tanjung temple, discussing the meaning of blood sacrifices.

Some of the 250 women carrying tall offerings to Kayangan Tiga
temple for the annual festival of Sesajian Peranian in Amban Desa.

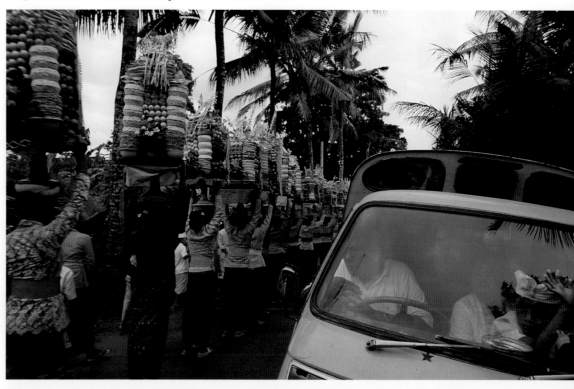

so that he cannot thrash. The men lift the hard belly cover, exposing all the muscles, organs, and a prominent beating heart. They scoop out the blood, forcing the ladle down into the beast. To my hosts, reincarnation is this turtle's destination. The jugular veins are cut and his heart pumps on long after it is removed, hence the pervasive and ancient belief in the fortitude of turtles.

A localized power blackout occurs. Cigarettes glow like fireflies, the pot boils, and the radiance of Denpasar illuminates the sky to the east. The Banjar headman prepares ritual offerings: thirteen small packets made of minced turtle's organs, one for each child. We leave by flashlight as he places them at the "spirit house" by the driveway, at the corner of the yard.

In the kitchen, a man tells me that his brother is with the U.N. peace-keeping force in Cambodia. He shows me a picture. The cooking continues through the night until morning, preparing multiple dishes for tomorrow's many guests. Strong coffee is served at regular intervals. With dawn everyone dresses traditionally in a kain panjang, a fine shirt, sash, and headband.

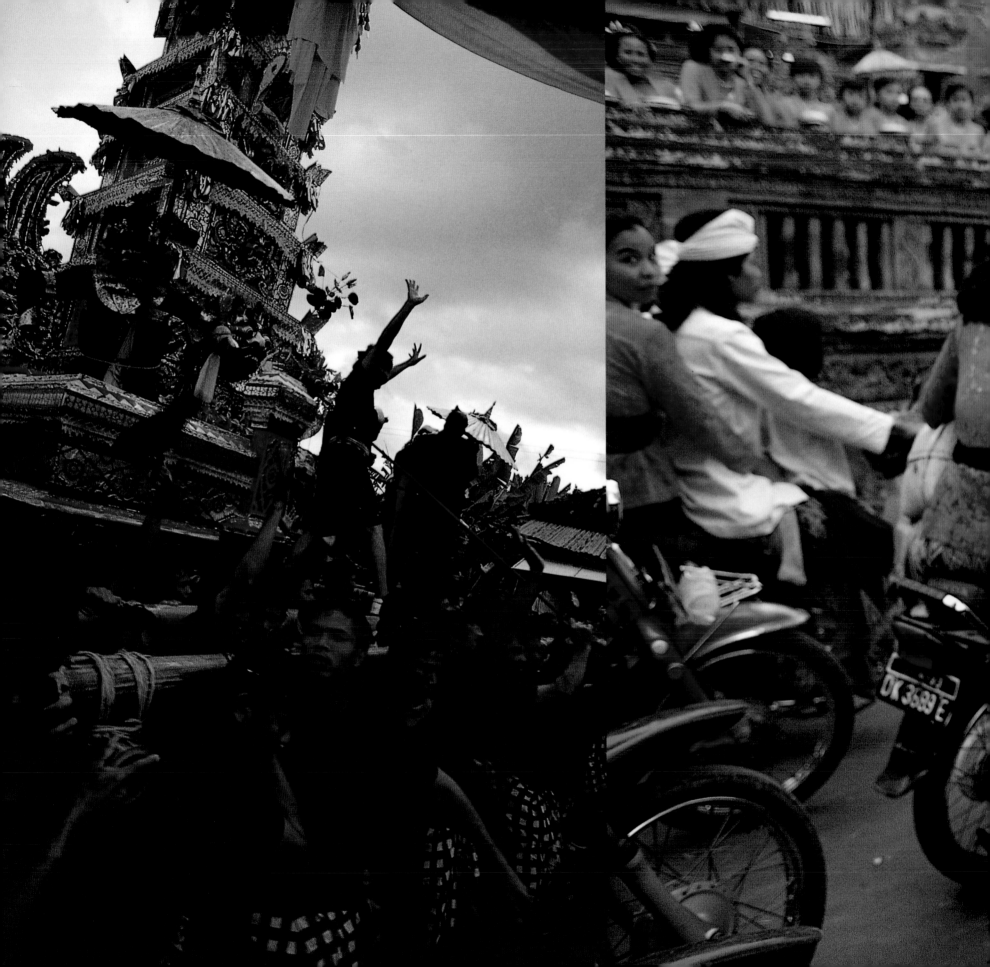

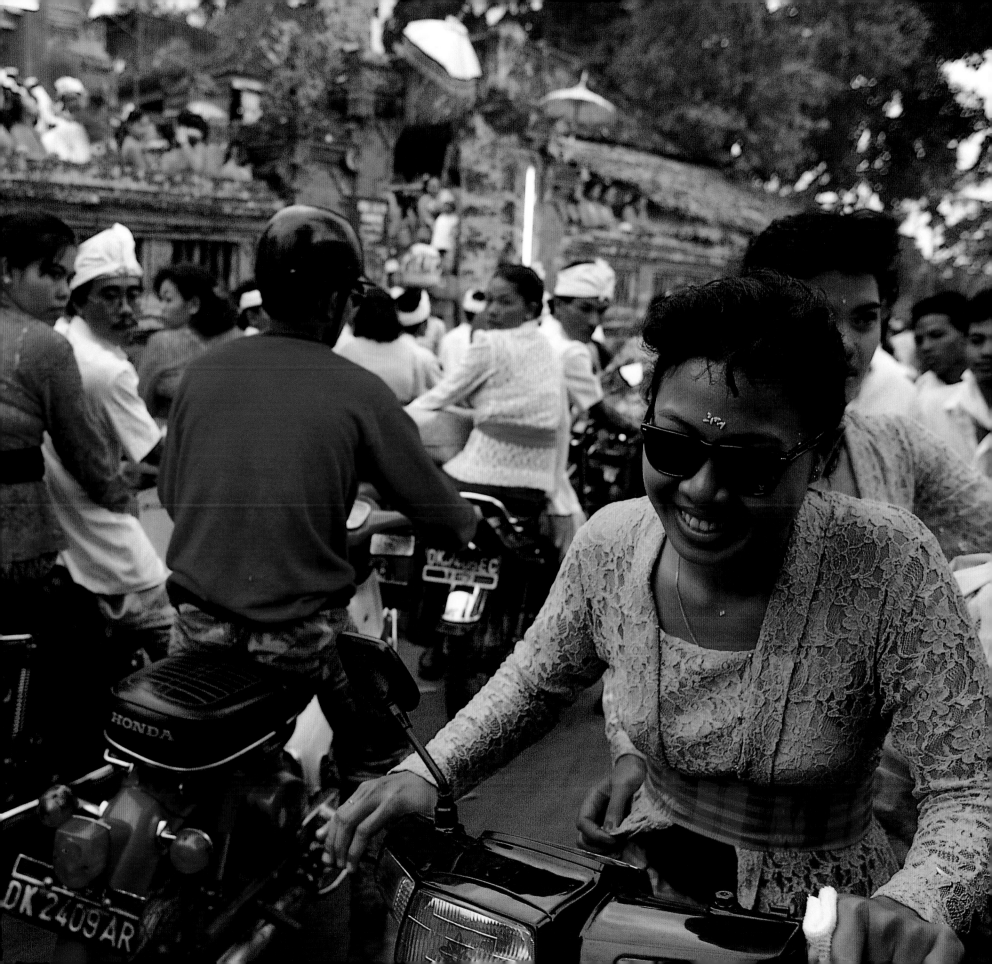

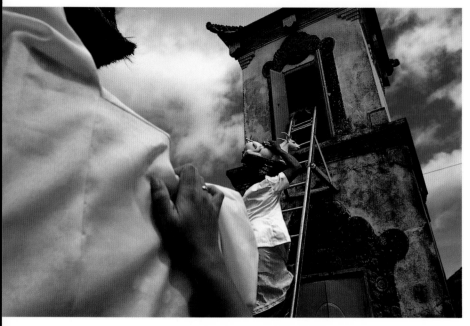

Removing fetishes from the temple towers at Tanjung Benoa for Odalan, which occurs every 210 days according to the Pawukon calendar.

Women carry *banten tegeh* on their heads. The elaborate tall offerings are made from fruit and rice cakes and are delivered to their local temple.

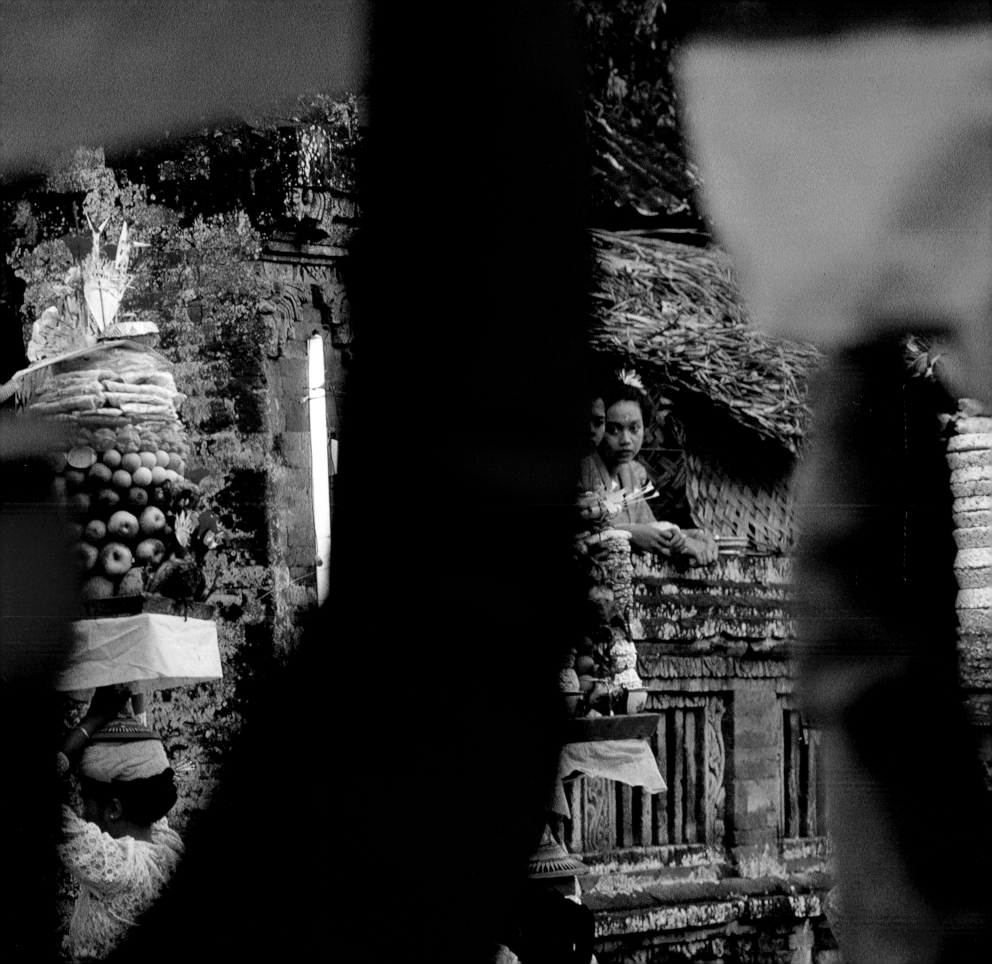

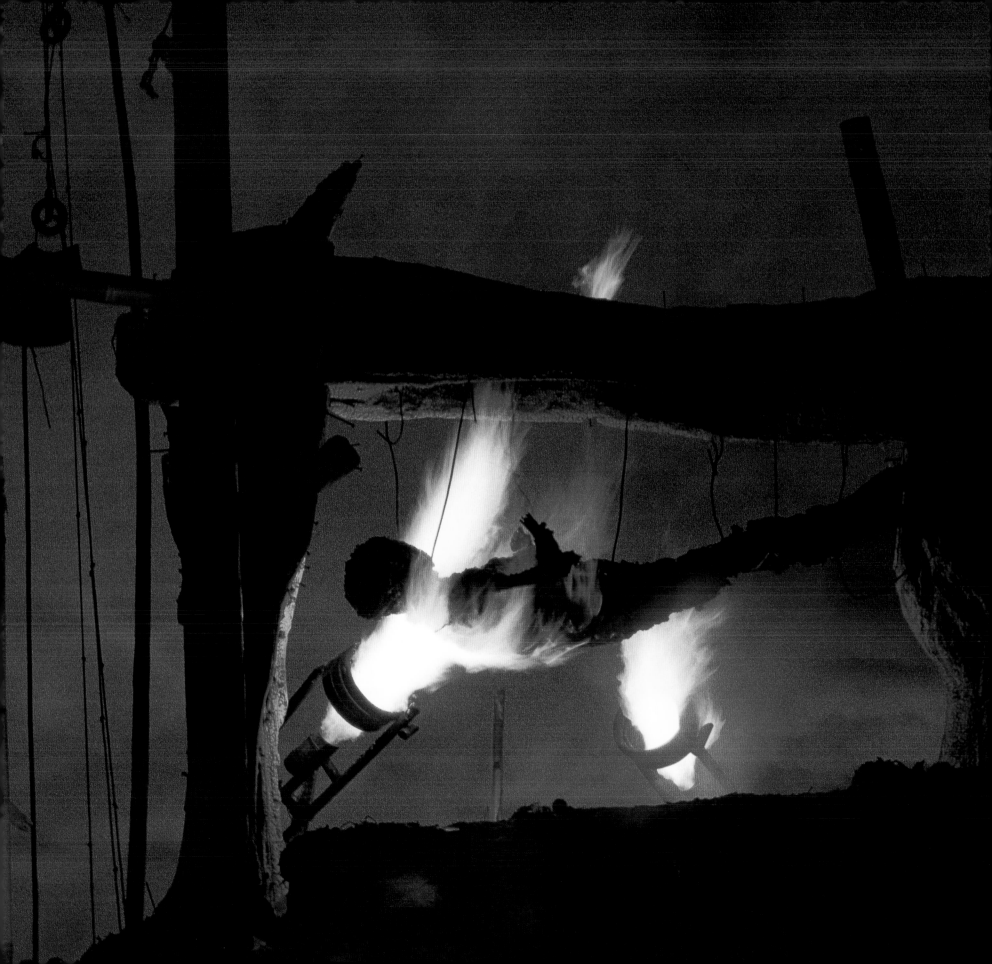

The cremation of the raja of Gianyar, January 1993. The shell of the cow-shaped sarcophagus is
all that remains around the corpse as high-pressure gas burns below.

The last of the cremation towers to be burned. Below Bhoma's burning wings is the symbolic
hump of Bedawang Nala, the world-bearing turtle.

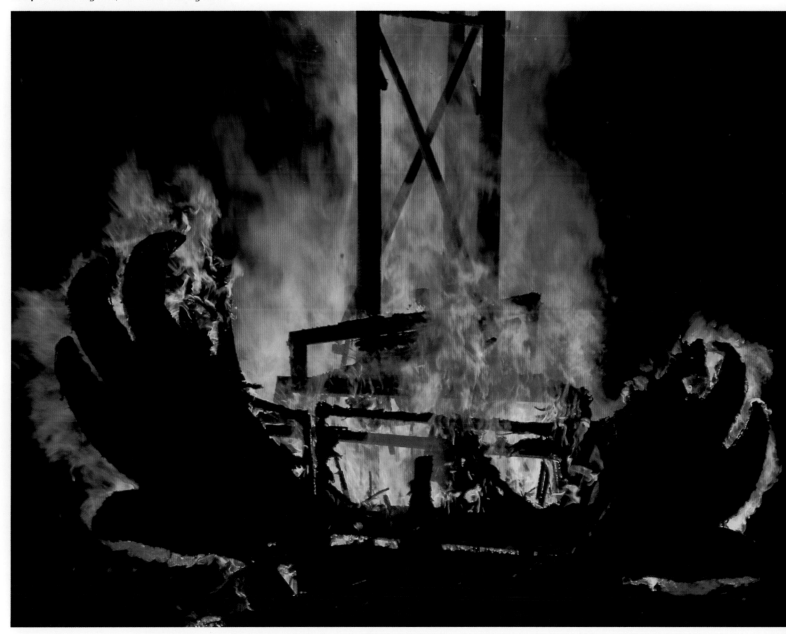

*Arriving from a neighboring village, a pedanda, or priest, comes to bless the children. Guests begin to
arrive, and after the blessing we feast. I'm tired from the night before and dazed by the women dressed
like goddesses in spectacularly detailed finery.*

77

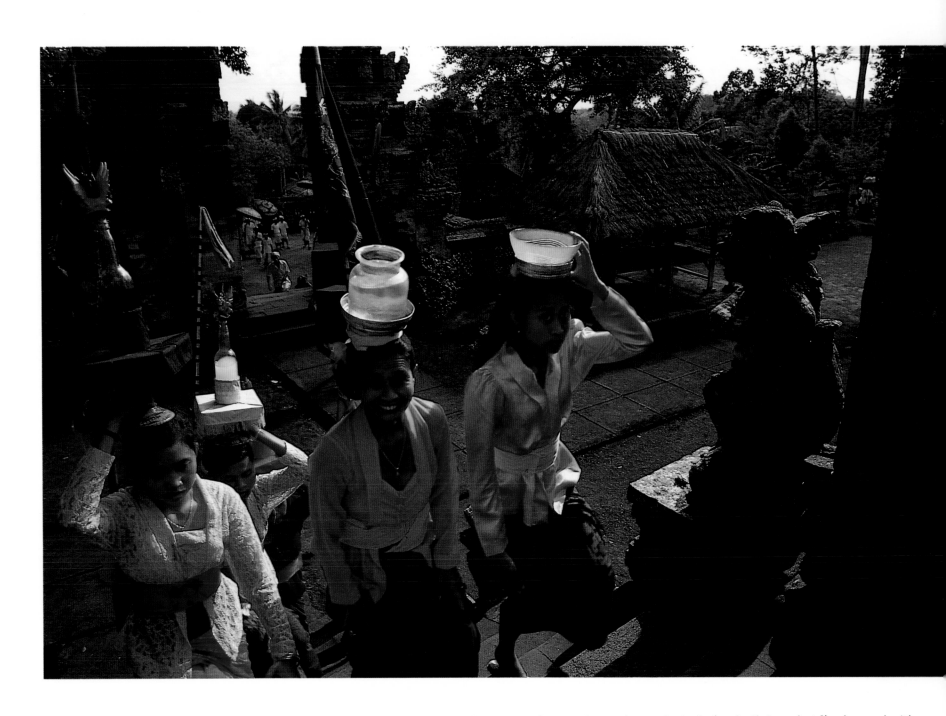

Holy water is brought to Pura Kehen, the ancient temple at Bangli; its origins date to perhaps as early as the tenth century.

I continue my own ritual, returning by morning to the turtle dealer's, clarifying what I've learned with the village pedanda, waiting for other festivals. It is early. I try not to be judgmental, but I've learned that the turtle merchant eats pig on special occasions, which makes me think domestic animals could fulfill most uses of the turtle.

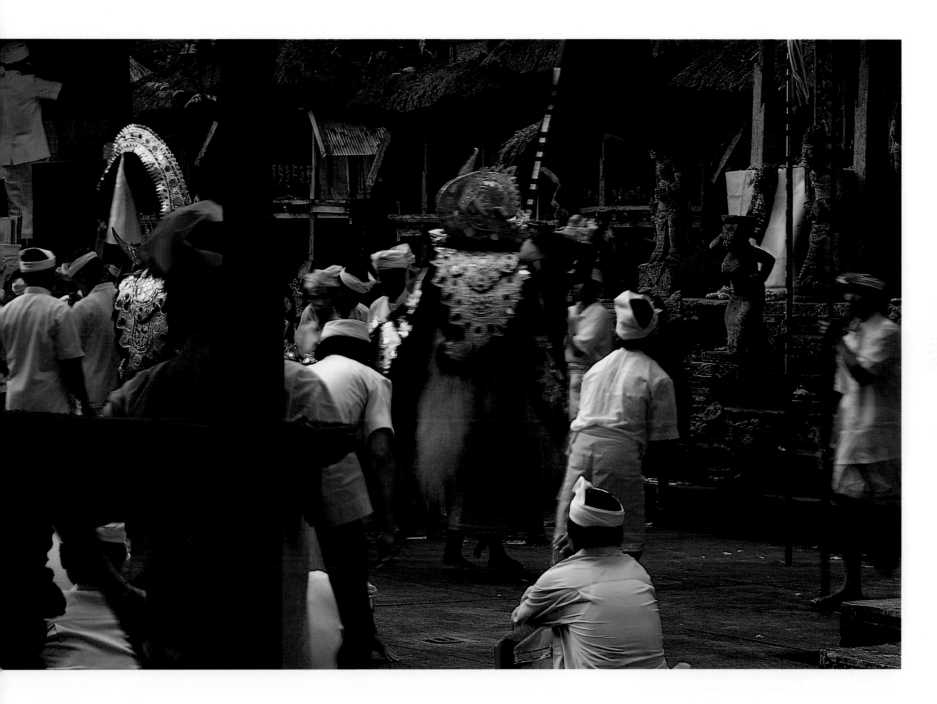

My friend Bapa Kerig in Tanjung Benoa told me that about 1958 he witnessed a variation of the ritual when children reach three months of age. The father had read in some obscure religious text that the children should ride live turtles three times around the Jaganata Temple in Denpasar. The man rented the live turtles and then returned them. Bapa Kerig thought this was strange, but an elderly priest confirmed it—in the old days turtles were sometimes set free as part of rituals.

Signifying the battle of good and evil, a *barong* from one of Bangli's neighboring villages is welcomed at Pura Kehen after a long march. At the stone base of the main shrine to the right is the long-nosed Bedawang.

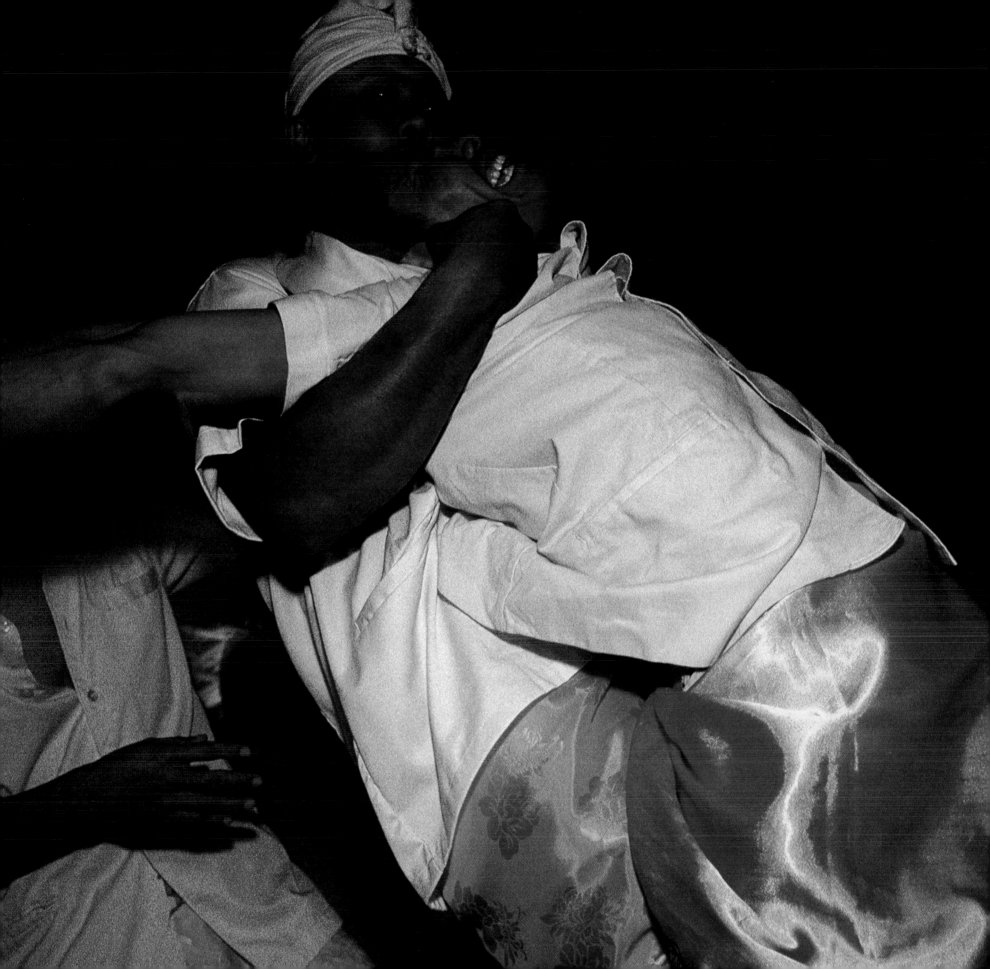

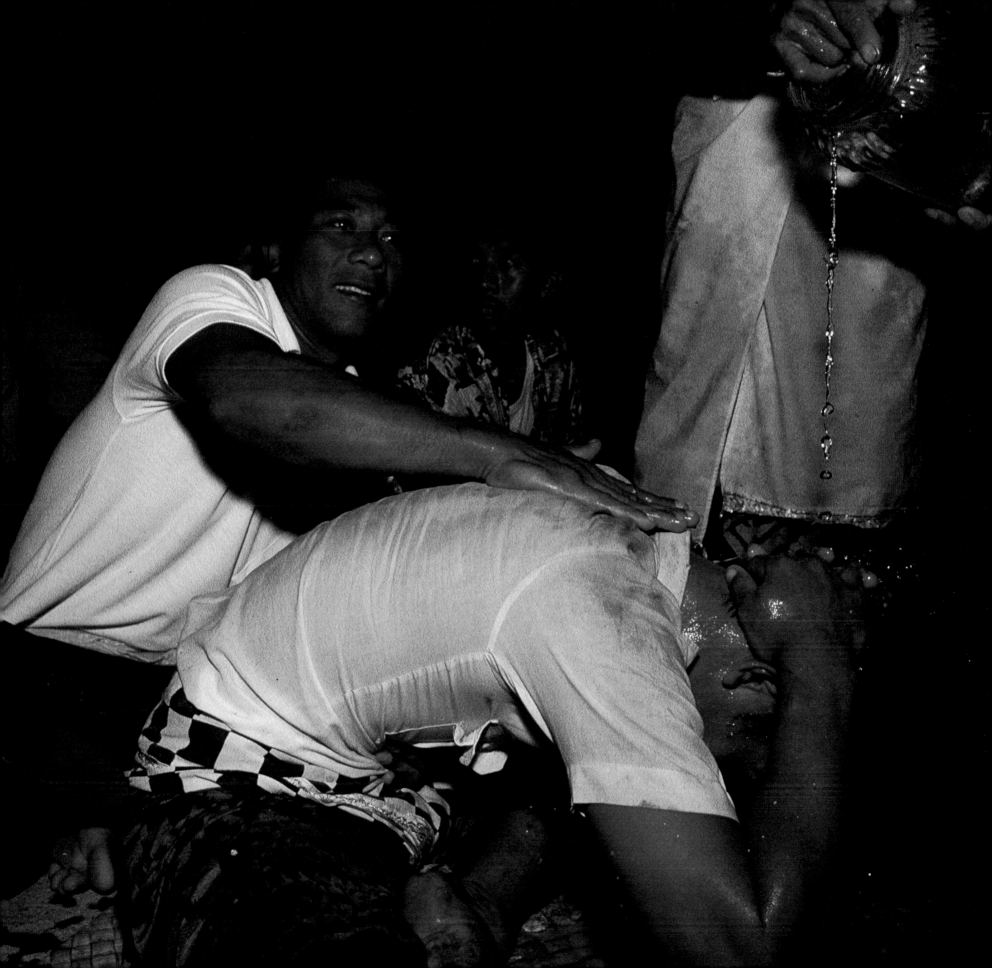

Previous page, left: Repelled by Rangda's negative energy, many villagers are driven into frenzy during the Barong ceremony for Odalan at Tanjung Benoa's central temple. Rangda symbolizes the dark side of man. *Right:* A priest administers holy water to calm one of the dazed villagers.

The following morning is quiet at Tanjung Benoa. This is the main temple that the turtles must pass on the way to festivals elsewhere in southern Bali.

Following Odalan, idols, *barongs*, gongs, drums, and ceremonial gear are once more stored in the temple.

A friend in the village invited me to attend a tooth-filing ceremony north of Denpasar. There are six young women and four young men undergoing Mesangih; a pair of them will be married at the conclusion. We pick up a boy from Jembaran who is a relative, and travel through Denpasar's maddening traffic to the sanctuary, where ladies dressed in gold and boys in makeup are waiting.

Tooth filing is not a savage practice. To the Balinese, it is a ritual of beautification, a coming of age. By removing the points of the teeth, the animal nature in man is killed, inspiring a higher level of spiritual refinement. Usually this occurs before marriage, but not before a woman's first menstruation. All Balinese undergo it. It is a vital rite, so important that no expense can be spared. The ancestor deities are summoned. Musicians, decorations, and an elaborate banquet honor the many guests. The finest foods, including turtle, are served with other delicacies.

Wind, water, fire, earth, and ether are the five elements of the universe. Atman, the soul of man, resides in the human body created from these substances. There was a great cremation, a mass spectacle for Anak Agung Gde Oka, at the palace of the raja of Gianyar. To my knowledge, no turtles were consumed; it was the symbolism that I found intriguing. A jostling procession carried the empty sarcophagus, in the figure of a bull, along with several tall cremation towers, through the streets past throngs of onlookers. In the heat of day they reached the cremation grounds, close to the temple of Shiva, creator and destroyer. The royal corpse was moved from the high tower to the pavilion and set into the solid wood sarcophagus for prayers and eventual burning. Fuel, poured liberally on the sarcophagus, sets it afire, encouraged by high-pressure gas torches placed below the bull. The son of the deceased explained that this saves on wood (for environmental reasons). His father's physical body is returned to the cosmos, freeing his soul to the heavens, for reincarnation.

Late at night, after waiting out the rain, the tower that carried the corpse is burned. The tower's structure symbolizes the Balinese concept of the universe. There are eleven levels. The base is Bedawang Nala, the mother turtle, on whose back the universe rests, bound down by two dragons. Above the turtle is Bhoma, scaring away evil spirits with its awful gaze, its outstretched wings now ablaze. The night is cool but I'm sweating from the heat of the fire. The remaining ashes are carried on the heads of women to the sea.

Egg Collecting

A large green turtle glides over the reef at Sangalakki, east Kalimantan.

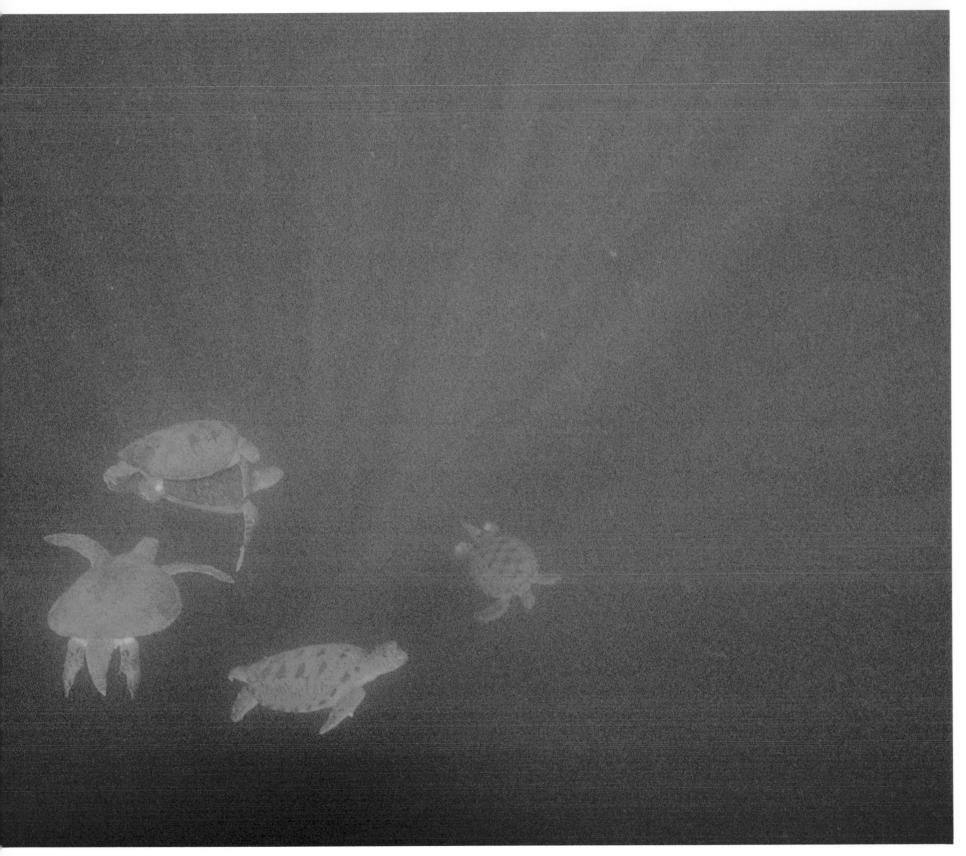

During the height of mating season at Sangalakki, three males challenge the already engaged pair in forty feet of water.

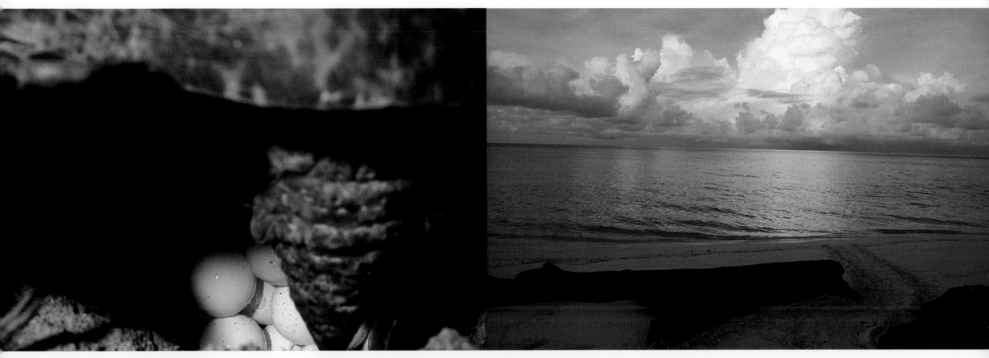

At night the female deposits her eggs in the nest she has excavated just above the high-water mark.

At dawn on the small island, the female's returning tracks are visible on the beach after laying.

East of Kalimantan and north of the Makasar Strait is an obscure group of small, low-lying islands that shelter green-turtle rookeries. These islands are part of a government turtle concession supplying the domestic turtle-egg market in Samarinda on Borneo's Mahakam River and in Tanjung Redeb, the historical site of Joseph Conrad's **Lord Jim.**

Sangalakki is the most productive of the four islands, and I spend many mornings with the resident egg collector, Ba Tambouli, an Indonesian Muslim. We meet at 5:45 A.M. each day when he begins his course around the island, following the turtles' tracks to locate the nests. Bapa, as I call him, knows this routine well. He has been working here since 1937, when he was sixteen. Using a steel rod to poke the sand, he locates the hole beneath and then excavates the eggs. Bapa's grandnephews carry these to a

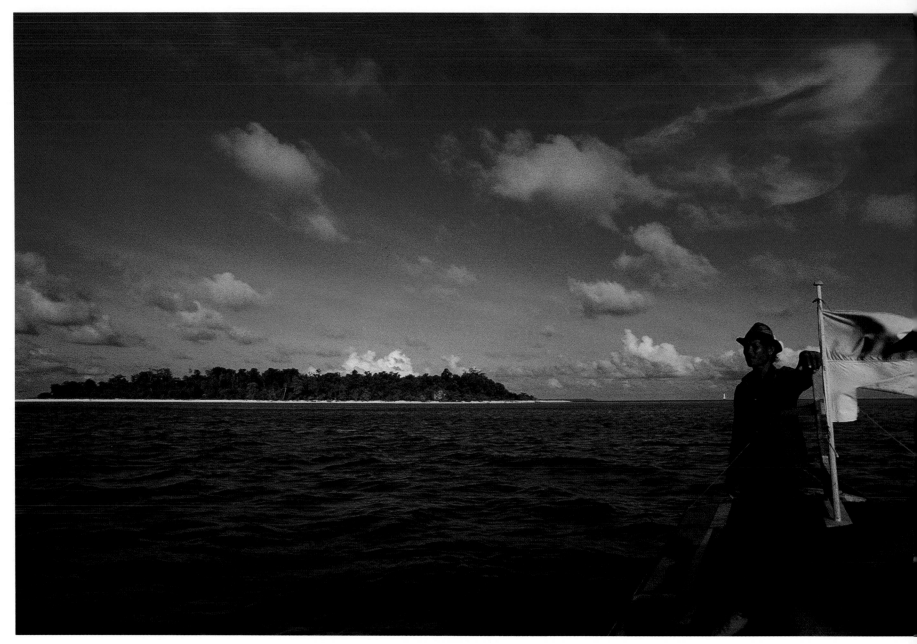

Sangalakki, seen from a small fishing boat.

dugout canoe that they pole around the island. He keeps track of the number of nests by repeatedly creasing a strip of pandanas leaf at his waist. At the other end of this calculator he marks the turtles that came ashore but didn't lay. In March as many as eighty turtles lay eggs each night, on an island that we walk around in thirty minutes. The egg collectors spare only the nests they miss, which is only when an early-morning downpour obliterates the turtle's tracks.

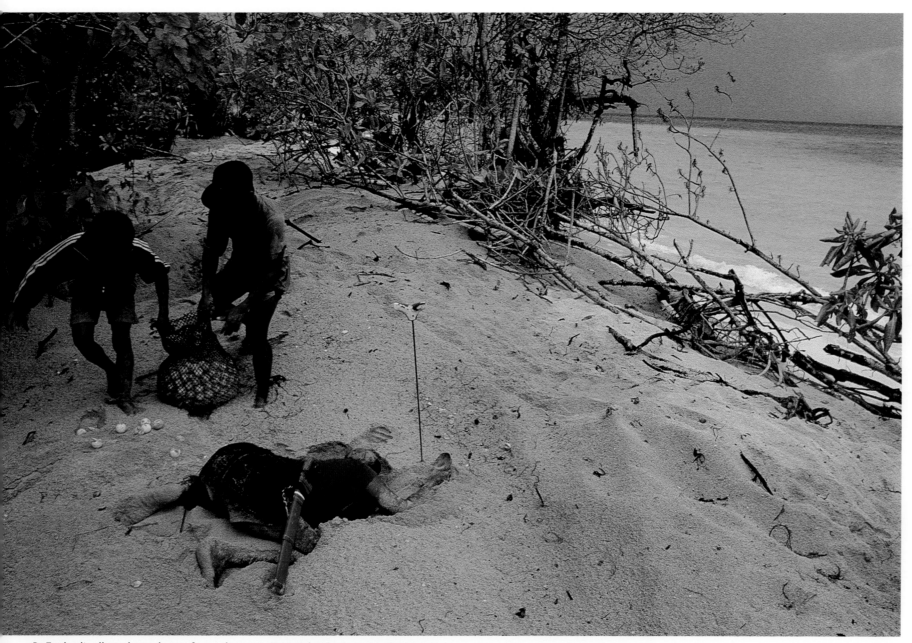

Ba Tambouli collects the turtle eggs from a deep nest. His grandnephews are bagging the take.

Bapa tells me that long ago he collected eggs from two hundred nests a day. He refers to that time as "the season of the Dutch," or pre-1949. He remembers World War II, when the Japanese came and took the turtles to feed their crews. His wife lives in the fishing community of a nearby island. They've had sixteen children. He tells me about the Filipino pirates who raid local communities and the coastal police who appropriate eggs, threatening with their guns. From the 1970s until recently the turtle

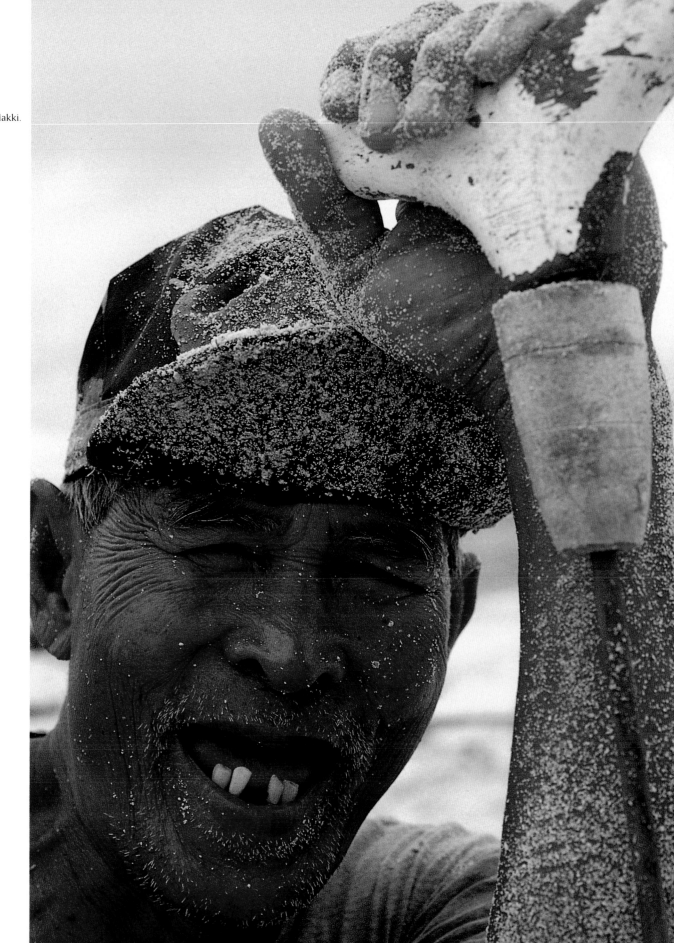

Bapa Tambouli, a longtime egg collector on Sangalakki.

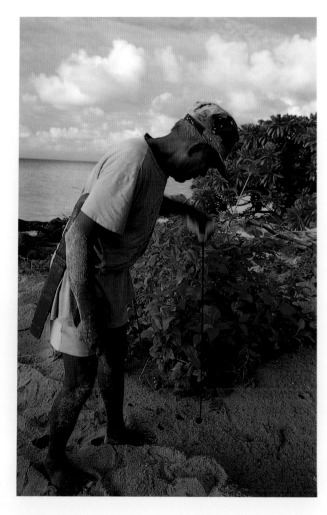

Bapa pokes the sand with a steel rod to locate the hollow cap at the top of each nest.

hunters who supply the Balinese market came here. Initially they offered $150 for mature turtles, but soon resorted to threatening the locals with their harpoons and stealing the turtles off the beach. Eventually there were arrests.

Bapa and his nephews wash and bag the eggs, storing them out of the sun. Turtle eggs have a soft, thick shell. They are durable, as though semi-inflated, and keep for several weeks without refrigeration. Every thirteen days the cargo boat arrives from Samarinda to collect the take. Most recently, over thirty-eight thousand eggs were loaded from Bapa's efforts alone. Before returning to the city the boat retrieves up to seventy thousand eggs from these four islands alone. This occurs every two weeks, as it has for decades. Eaten raw, the eggs are associated with sexual stamina. They retail for about twenty cents each in the marketplace.

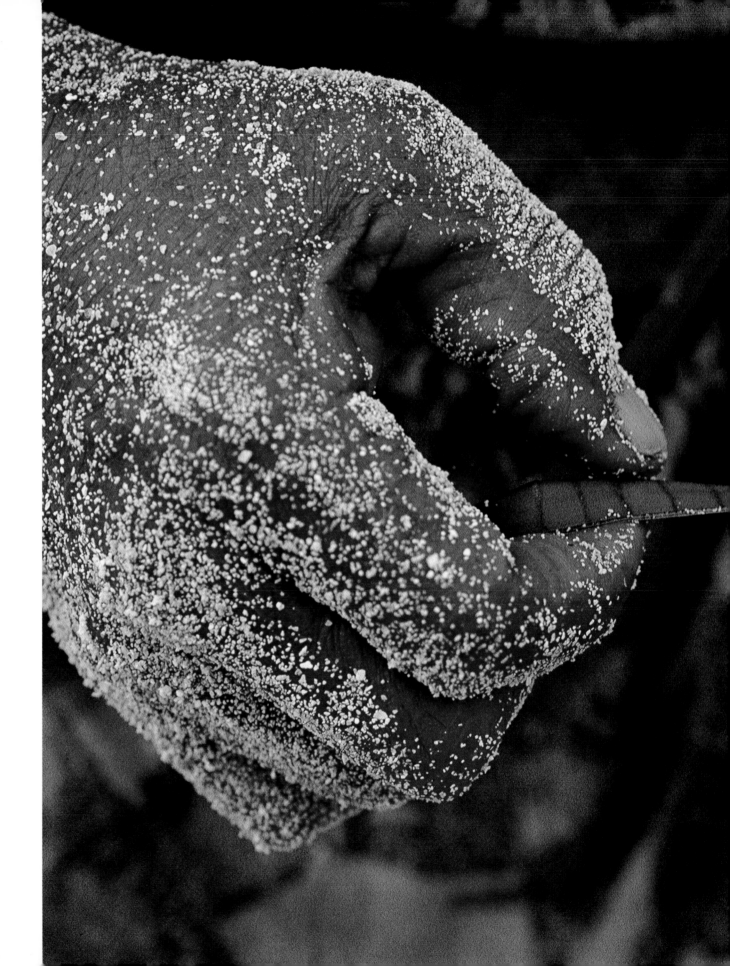

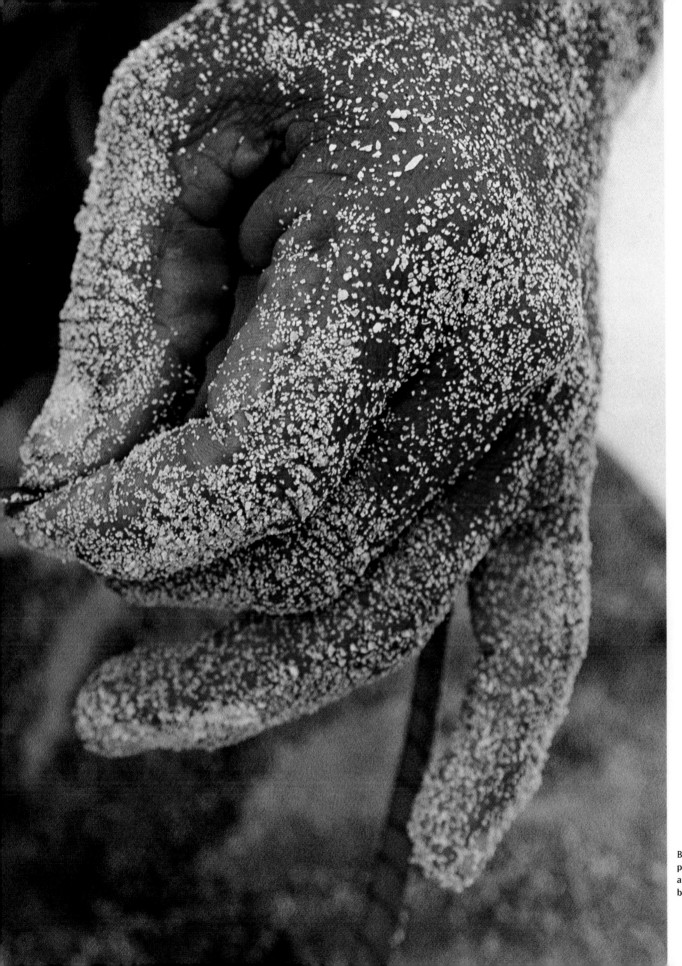

Bapa keeps a record each morning, creasing a strip of pandanas leaf at one end each time he collects a nest and at the other if a turtle's tracks suggest that she came ashore but didn't lay.

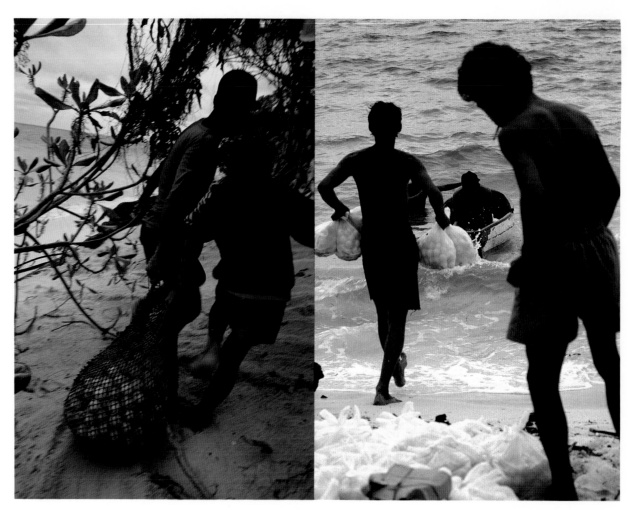

Bapa's grandnephews haul the eggs to the dugout canoe, where they are cleaned with seawater. This load is the take from a single morning. The eggs are counted and bagged for transport by boat to the port of Samarinda on the Mahakam River.

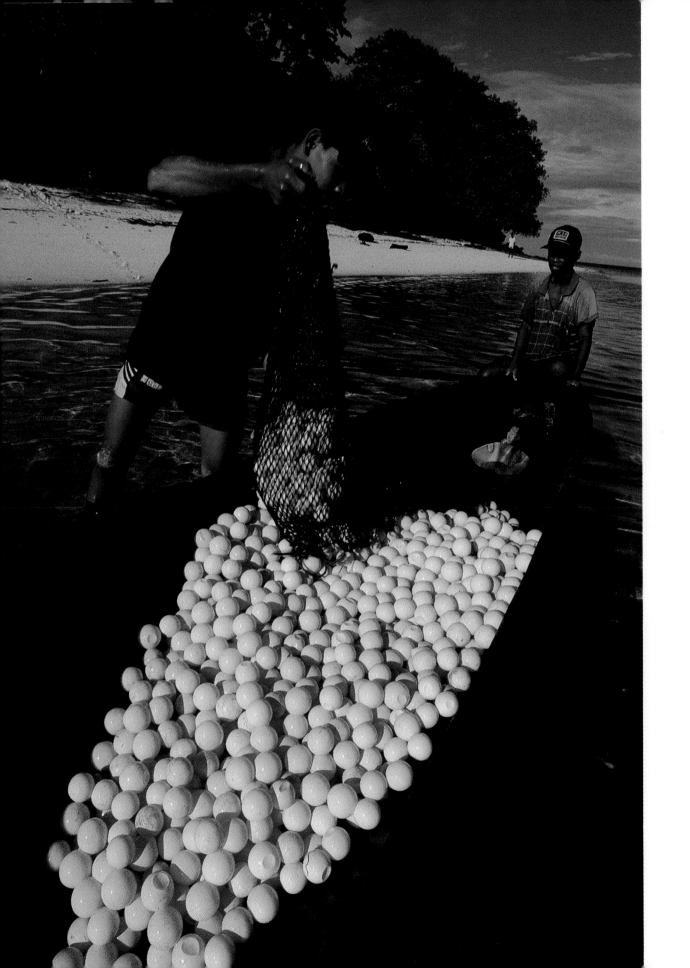

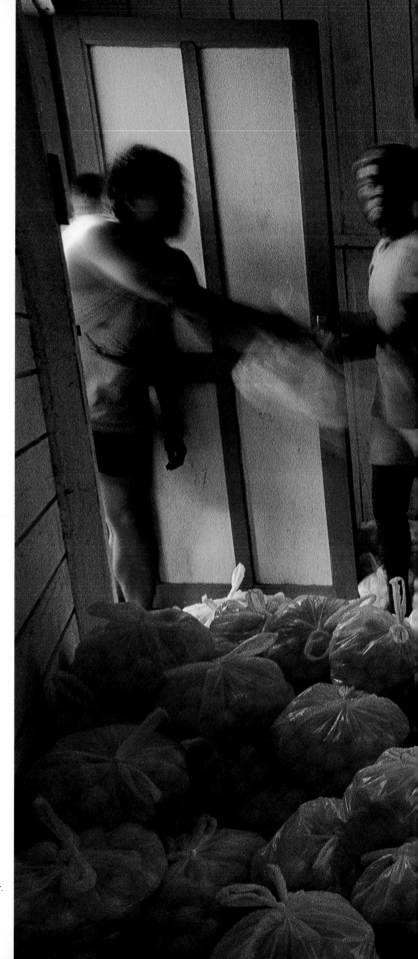

Stored out of the sun, the eggs keep fresh. Nearly 14,000 eggs are
accumulated in this room; they are picked up every two weeks for transfer.

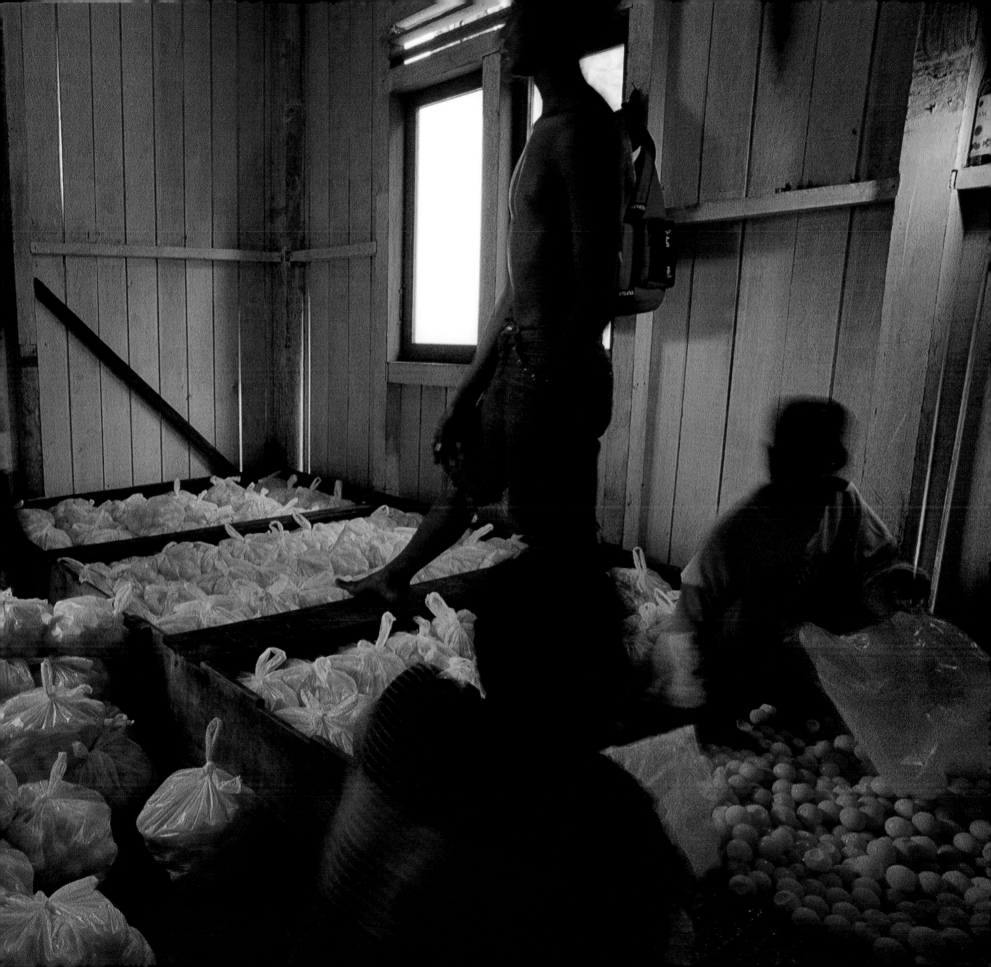

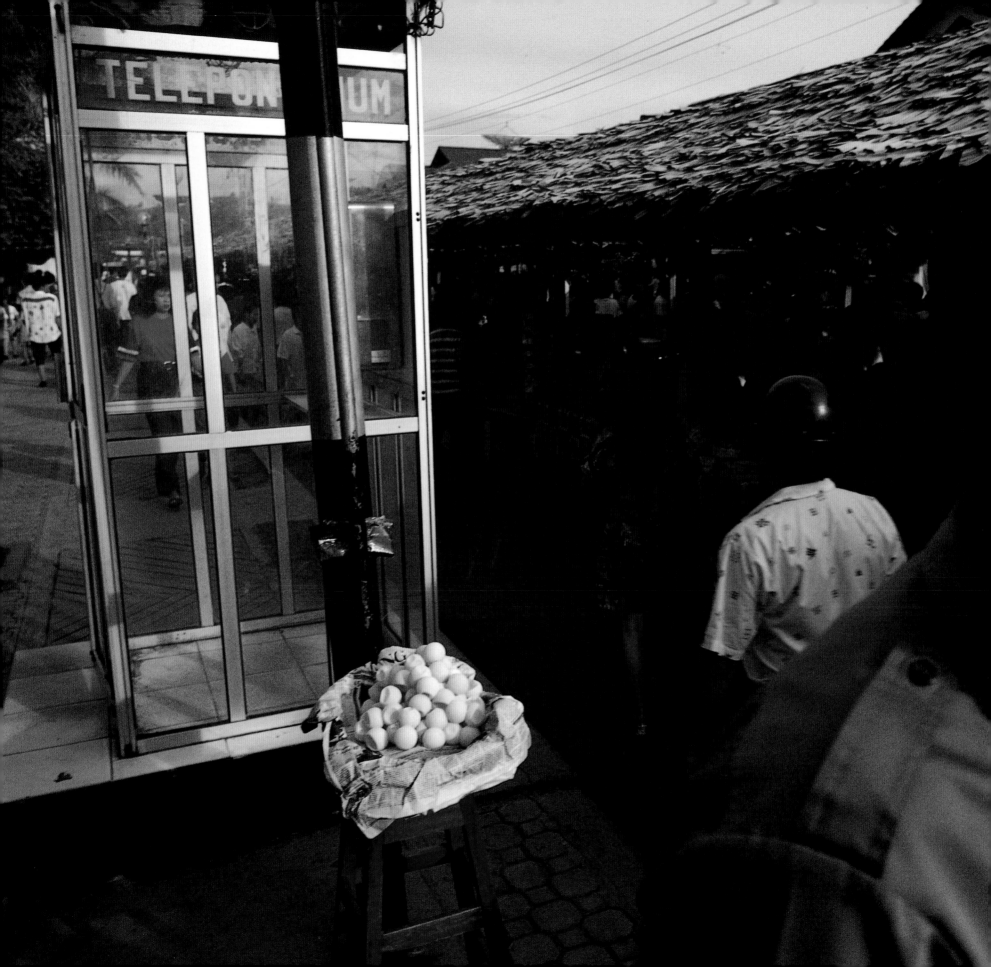

The eggs are distributed to individual vendors in Samarinda and elsewhere, who sell them for about twenty-five cents each. They are eaten raw and are frequently associated with sexual stamina.

There was an encouraging development on Sangalakki, though it is only one turtle rookery of many in Indonesia. Ron Holland with his company, Borneo Divers, based in Kotakinabalu, had arranged to purchase the turtle-egg concession for a lease of $48,000 annually. As of May 1993, the Borneo Diver's Rookery hatched several thousand turtles each day. Ba Tambouli was retained by Borneo Divers as night watchman and guide. He had become a determined environmentalist, still counting the eggs laid—and hatched.

Unfortunately, no sooner had the opportunity arisen to protect the turtles' nests than the local market price for eggs had increased. During the summer of 1994, Borneo Divers was forced to withdraw their entire operation from Sangalakki, forfeiting their investment in the turtle-egg concession. This was due to on-going local frictions between belligerent and occasionally violent police and military personel. Once again, Sangalakki's turtle-eggs are being consumed rather than protected; in an area claiming to be a national wildlife refuge. The regional government is now waffling on issues related to long-term protection of the endangered turtles. As well, there is low-level greed and corruption. Locals can't understand the immediate need for preservation of this turtle population when it has been a part of their diet for centuries. They don't comprehend that protecting these populations today ensures their numbers tomorrow. In the end, the governor of East Kalimantan and the government in Jakarta are the turtles', only hope. Their survival can be realized only if the government and the locals prove wise enough to implement and enforce stringent environmental laws. Environmental issues as a whole represent one of Indonesia's greatest challenges for the future.

The Great Festival

The grand procession enters the main compound at Besakih, Bali's foremost temple complex, for the centenary festival, Tri Bhuwana.

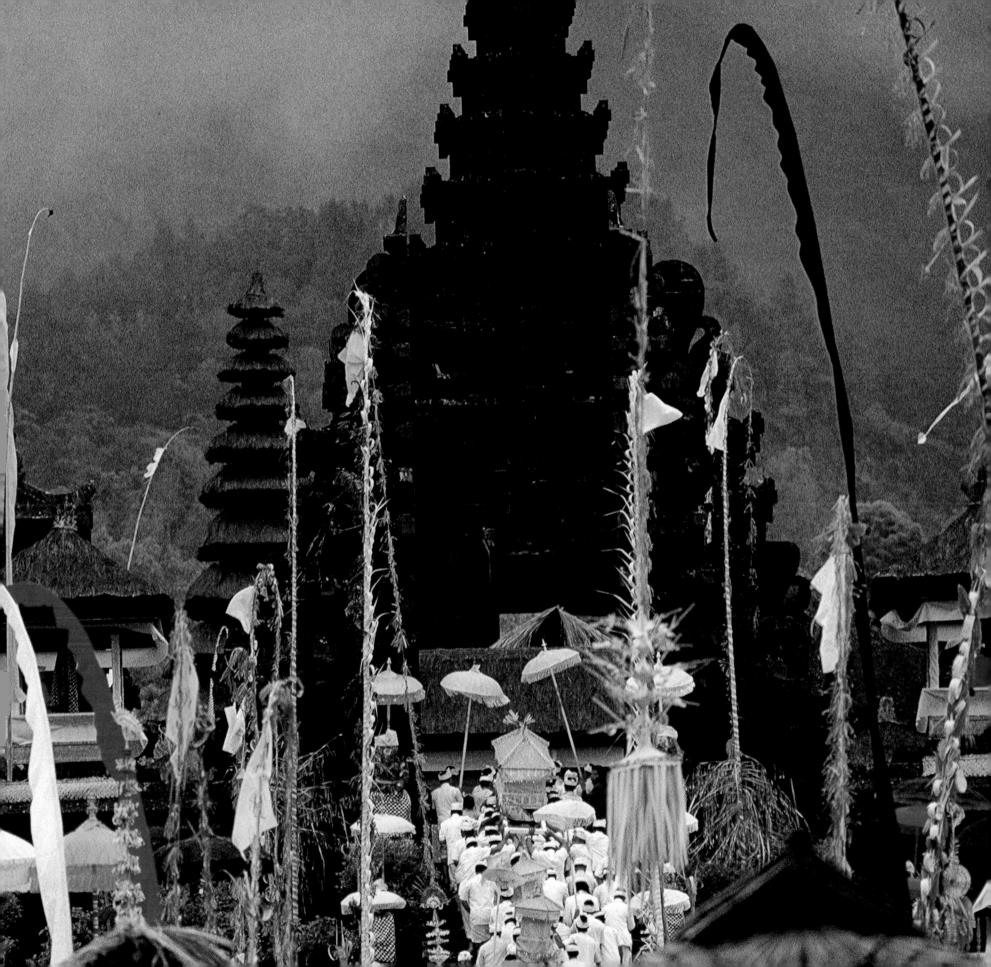

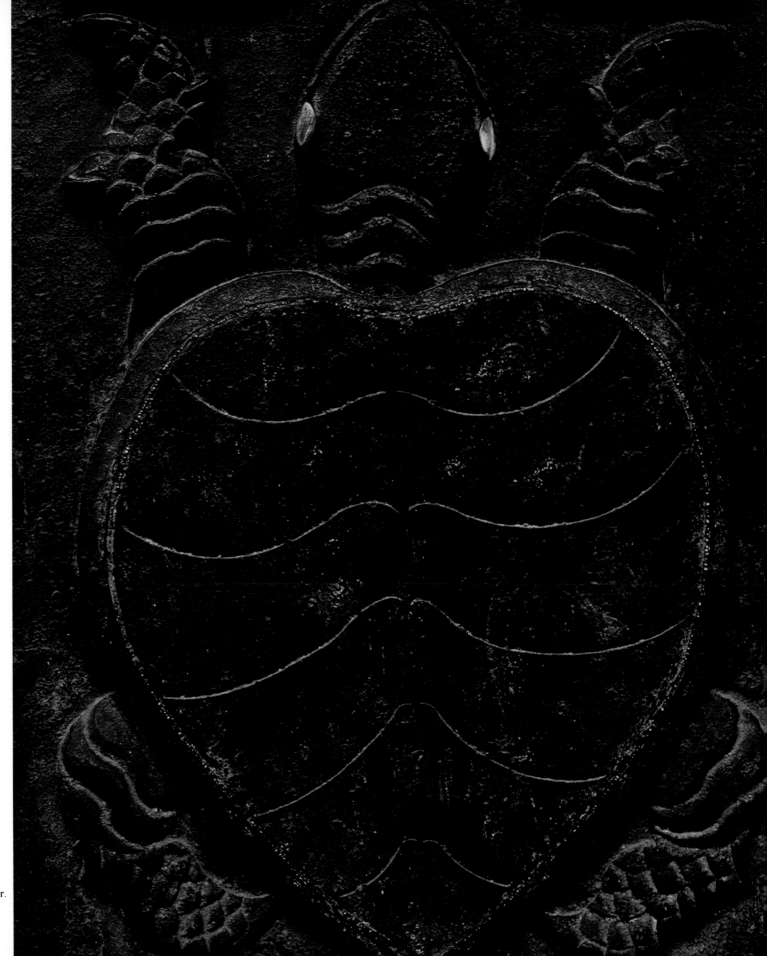

Turtle carving on a wooden door.

The procession reaches the black beach at Klotok after a thirty-mile march from the mountain. The spirit houses, **jempana**, symbolically enter the sea for cleansing by Varuna, god of the sea.

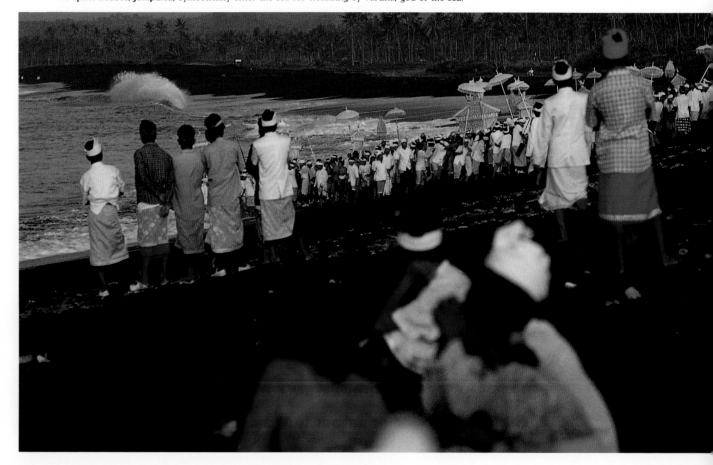

As fate would have it, I am honored to attend the once-in-a-hundred-year festival called Tri Bhuwana. This is a celebration to appease the gods and return balance to the universe, a universe that man has disrupted. The name of this festival translates to "Three Worlds," the highest being that of the gods, the middle world that of man, and the lowest, the animal kingdom. Tri Bhuwana took place from January to April 1993.

The temple complex at Besakih, built at one thousand meters on the southern slope of Mount Agung, Bali's highest mountain, has pre-Hindu origins. This is the mother temple, the geographic center of the

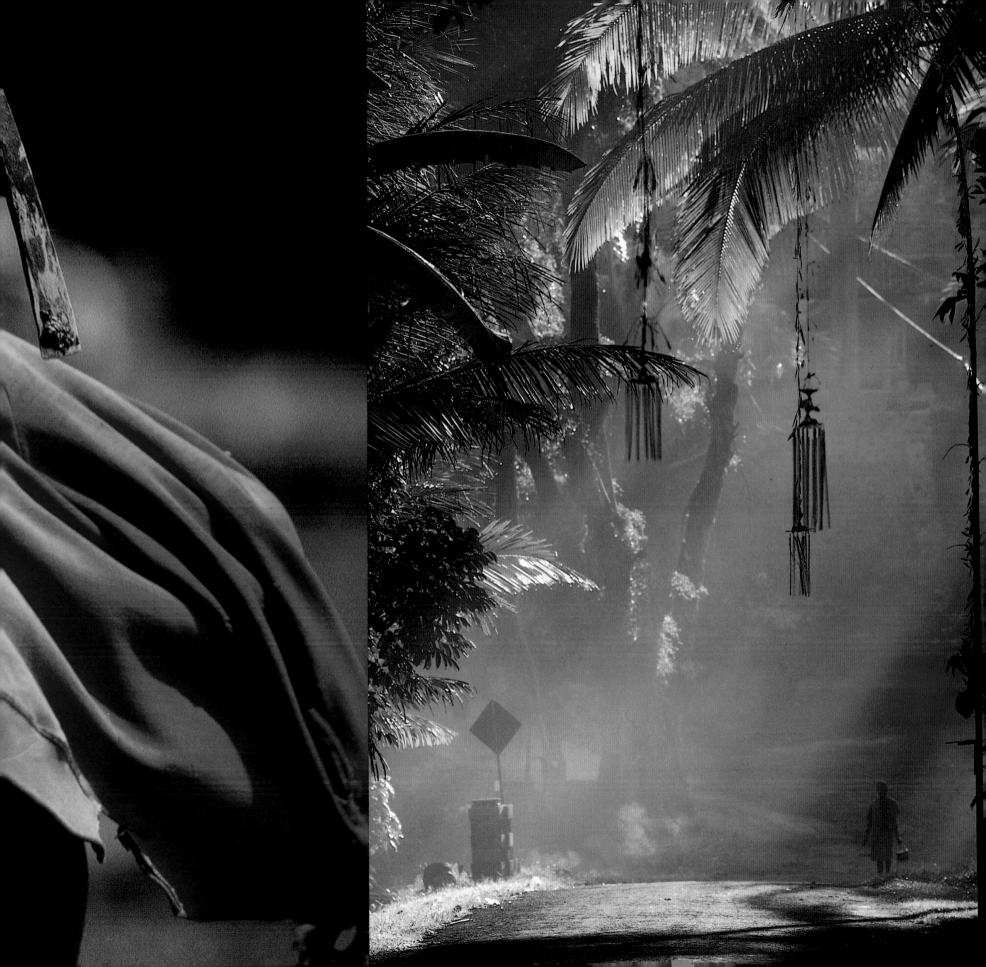

Previous page, left: A farmer comes down from the terraces above the procession where the spirits are thought to roam. *Right:* All along the route, the procession is followed by silence.

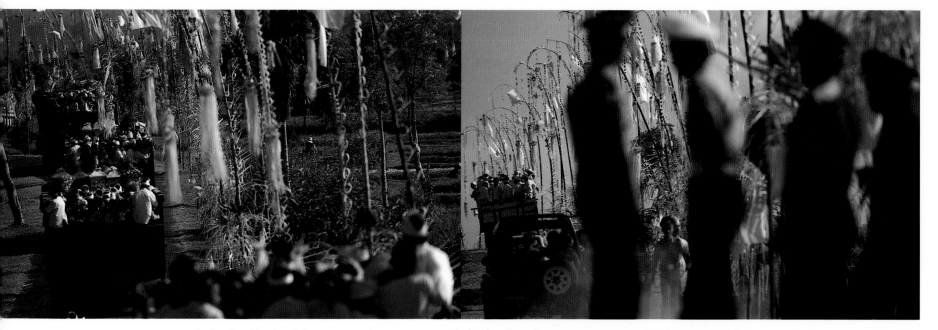

The beach at Klotok and the temporary shrines are set upon by hordes of worshippers, arriving in rented trucks and on foot.

Balinese universe. After months of preparation, prayers, and offerings, the temples are adorned and the people of Besakih form a procession some fifteen hundred strong. The road below my vantage point is alive; over twenty jempana, the spirit houses of the deities, are carried on the backs of the marchers to the sea, to receive the ritual cleansing of Vishnu. It is forty-five kilometers down to the black beach at Klotok, realm of the sea god Varuna. Usually Balinese worshipers travel in trucks and buses, but on this occasion most are walking. It is a round-trip of ninety kilometers over three grueling days.

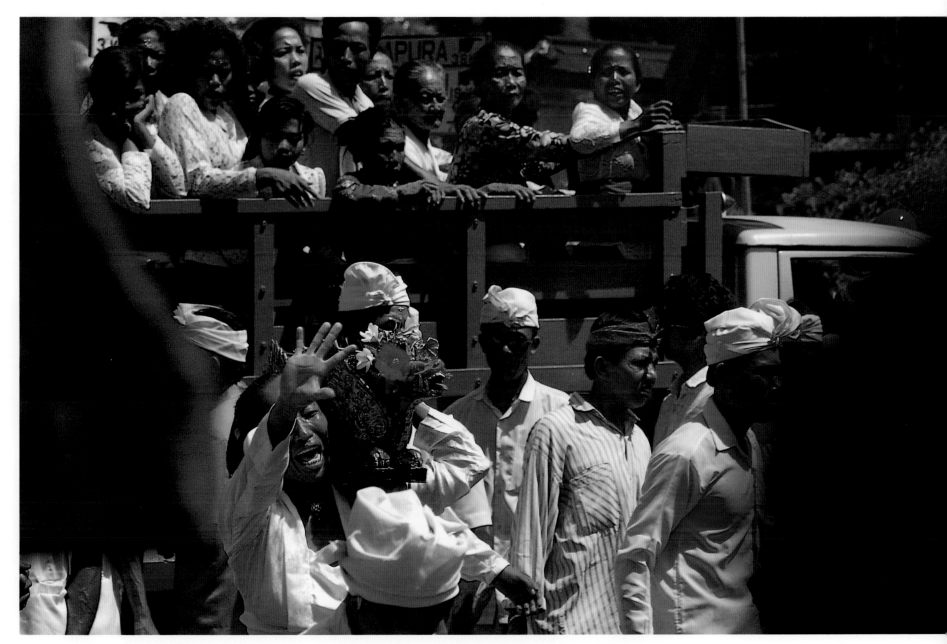

A woman goes into a trance at the crossroads in Klungkung, where the spirits pass.

I 've woken at 4 A.M. each day to join the procession on its dawn-to-dusk trek. Silhouetted against the new sky, prayer poles sway in the early breeze. There is a crescent moon, and a faint but growing sound approaches—sandals on asphalt, whispers, and bamboo flutes. By the roadside each village has prepared offerings for the spirits, with food and water for the marchers. Police cars lead the way, sirens and loudspeakers only adding to the spectacle.

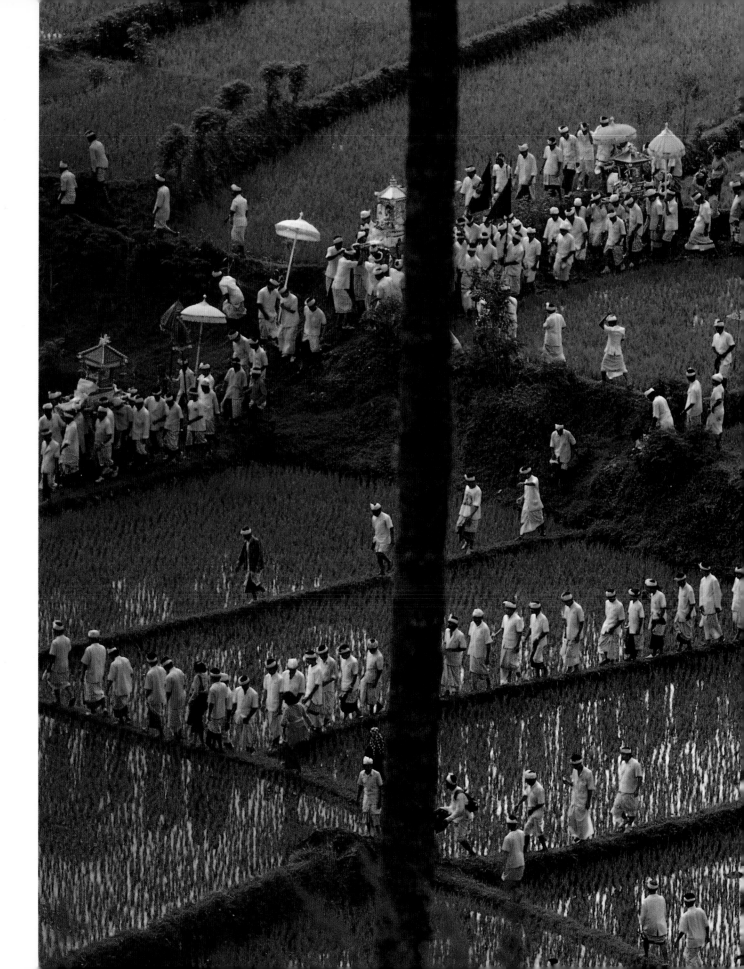

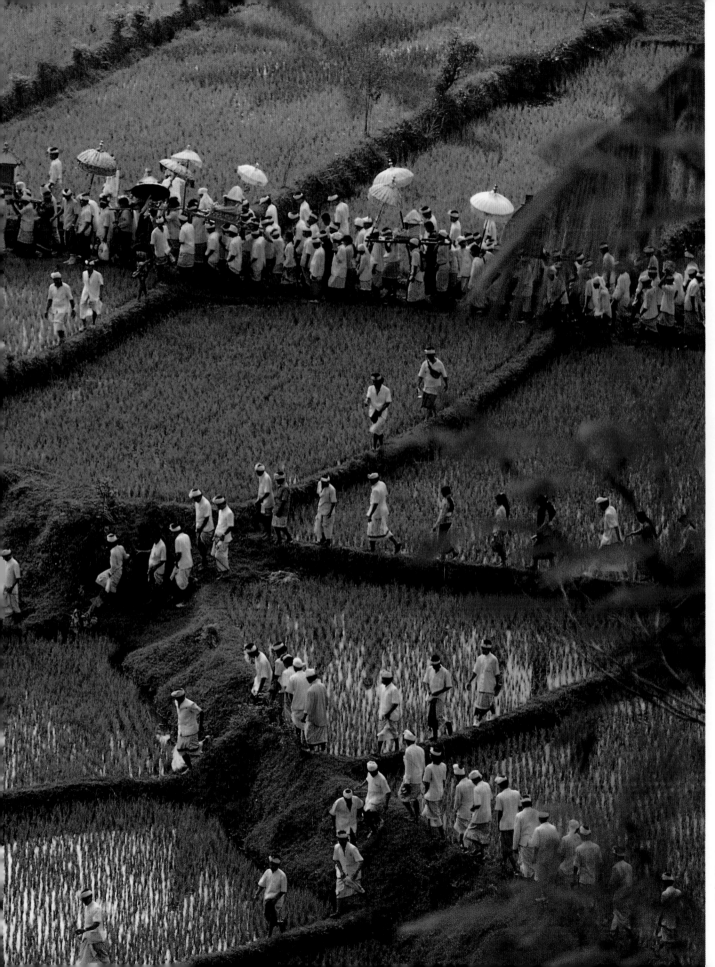

Near the village of Muunchun, more than twenty *jempana*, houses of the deities, are carried across rice paddies up a river valley toward Besakih.

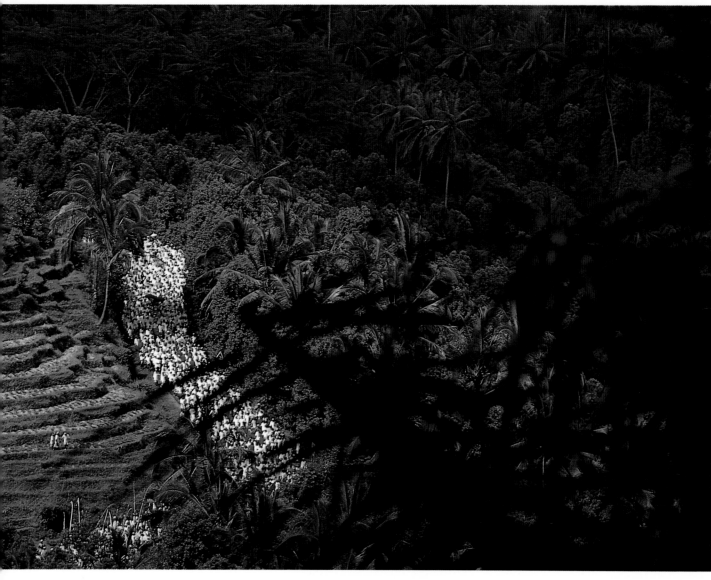

Tall flags mark the front of the winding procession on the main road leading to Besakih.

Framed by bamboo and flanked by dragonflies, the marchers approach. Portable kerosene lamps and flashlights light the road, gongs leading their way. They reach Tebola, at the mountain's base, well after dark, when theater and prayers commence. By 4:30 in the morning it is time for the final trek. To show respect, I'm dressed accordingly, Balinese style, staying just ahead of the procession.

A green turtle is draped in black, the color of Vishnu, as it is carried clockwise around the sacrificial enclosure.

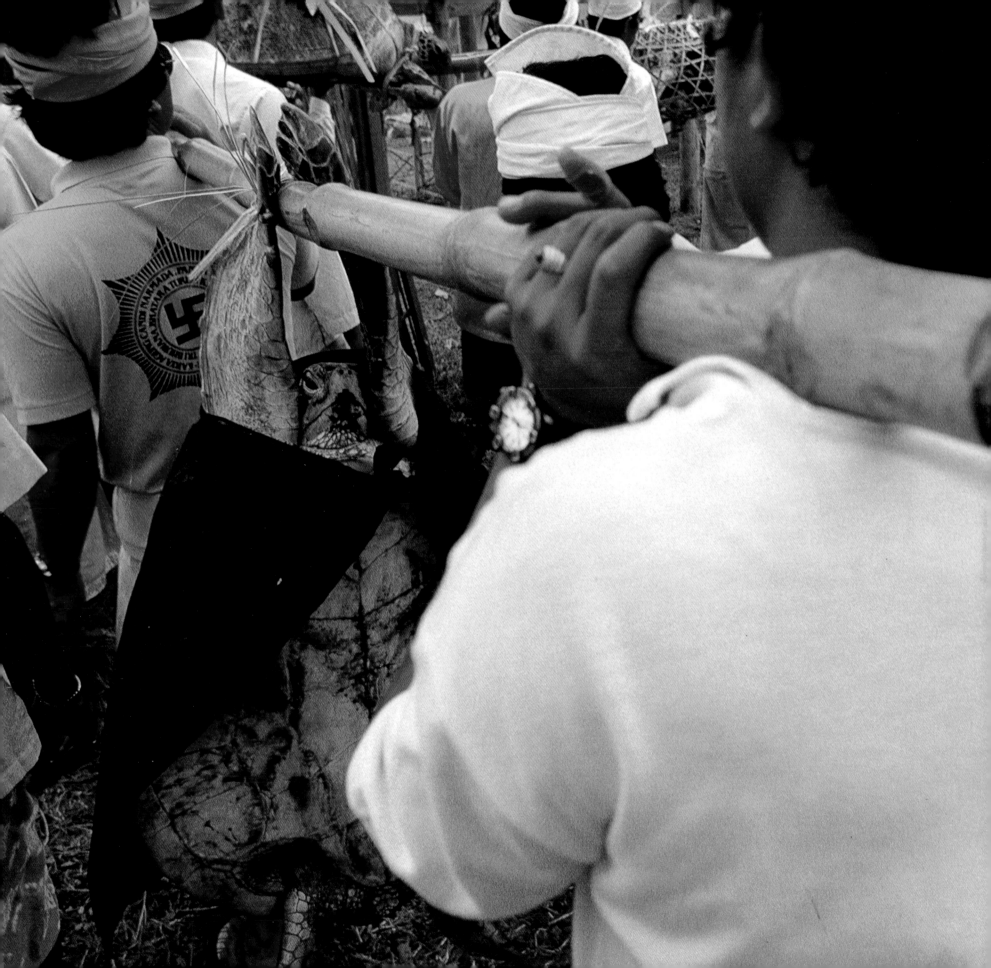

Women sitting below the altars within the sacrificial compound shade themselves from the midday sun.

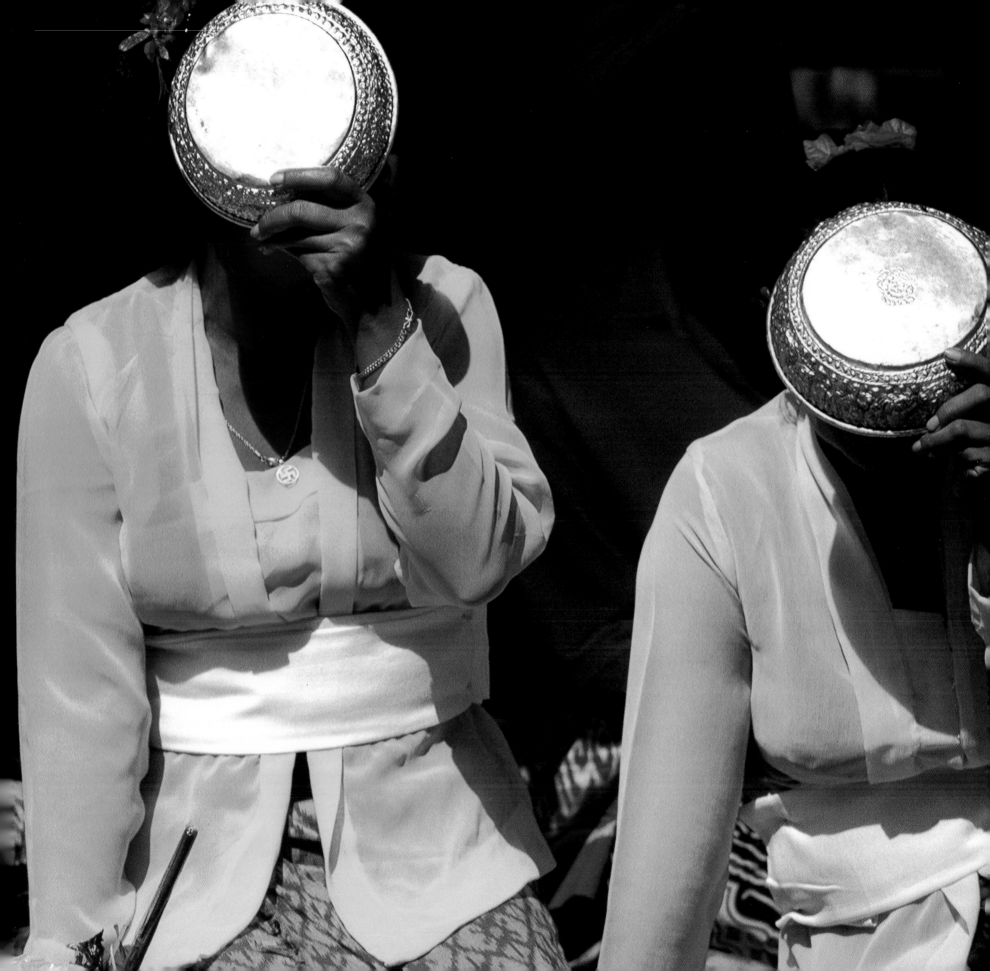

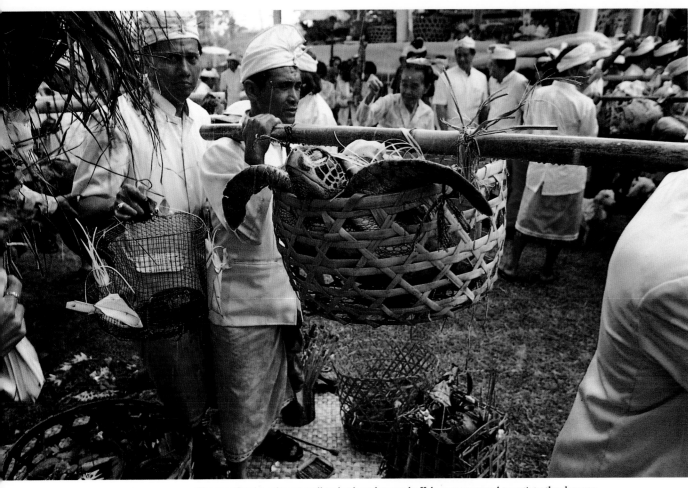

The sacrificial turtles, as well as lamb and water buffalo, are prepared to satiate the demons.
They are brought into the courtyard of Panataran Agung shrine.

Snaking through the countryside, the route eventually departs the small paved road and the procession begins the climb up a river valley as it approaches Besakih. Priests hail onlookers down from the ridges; they believe the spirits are above and must be guided back to the mother temple. From a terraced plateau to the west, I watch and photograph as the procession splits, defining the rice paddies in a fleeting image from Kipling's time. Eventually the spirit houses are heaved up the tiers and steep entrance to the great temple complex. Speakers pump out mantras, and Rejang, the sacred nymphs, dance to welcome back the gods. The spectacle numbs me.

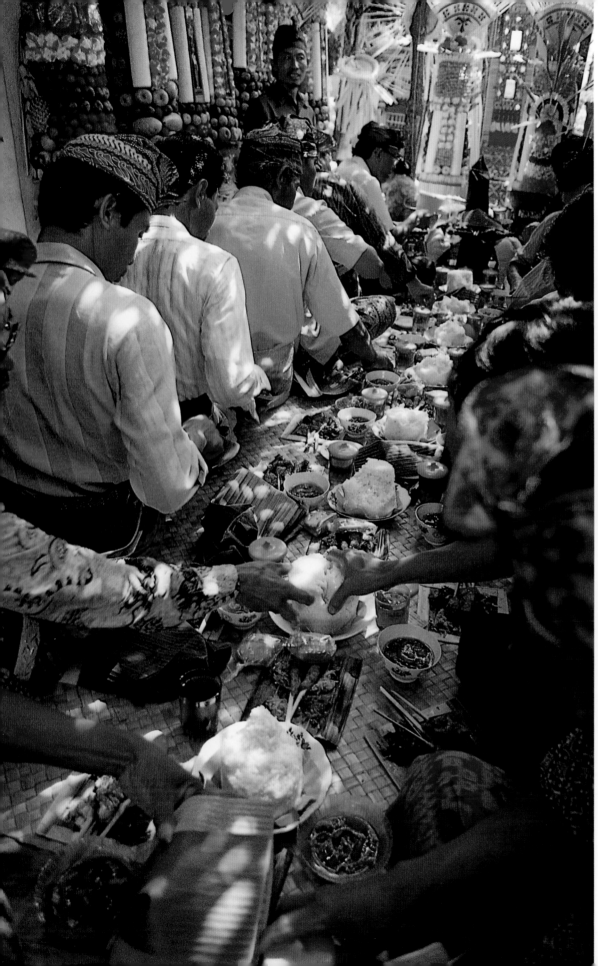

Turtle is prepared in numerous ways and served with rice for a ceremonial meal. The men take part first, the women and children afterwards.

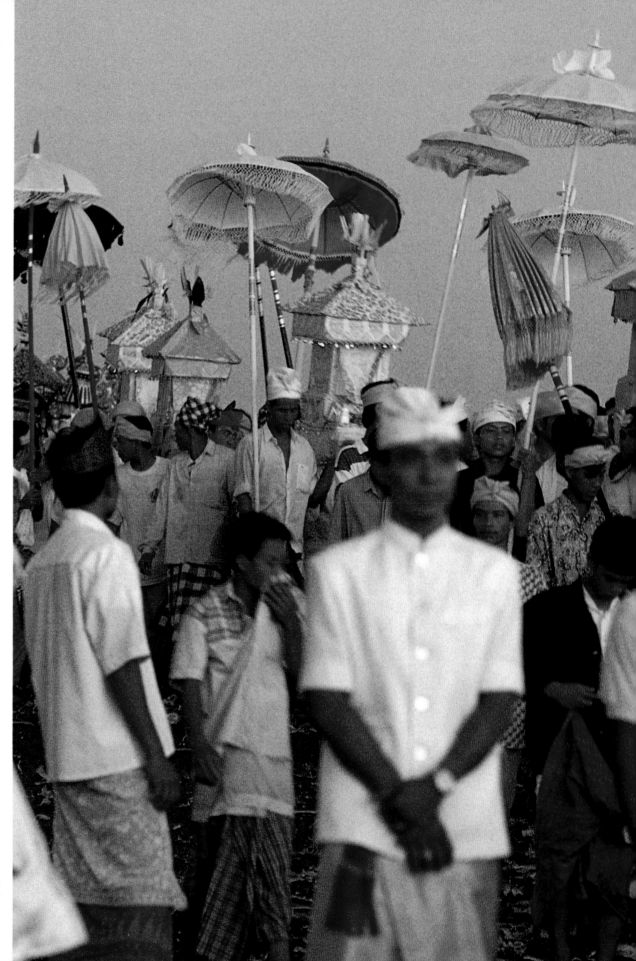

Parasols cover the *jempana*, shading the deities. They are carried on the shoulders of the faithful from the mountain to the sea and back.

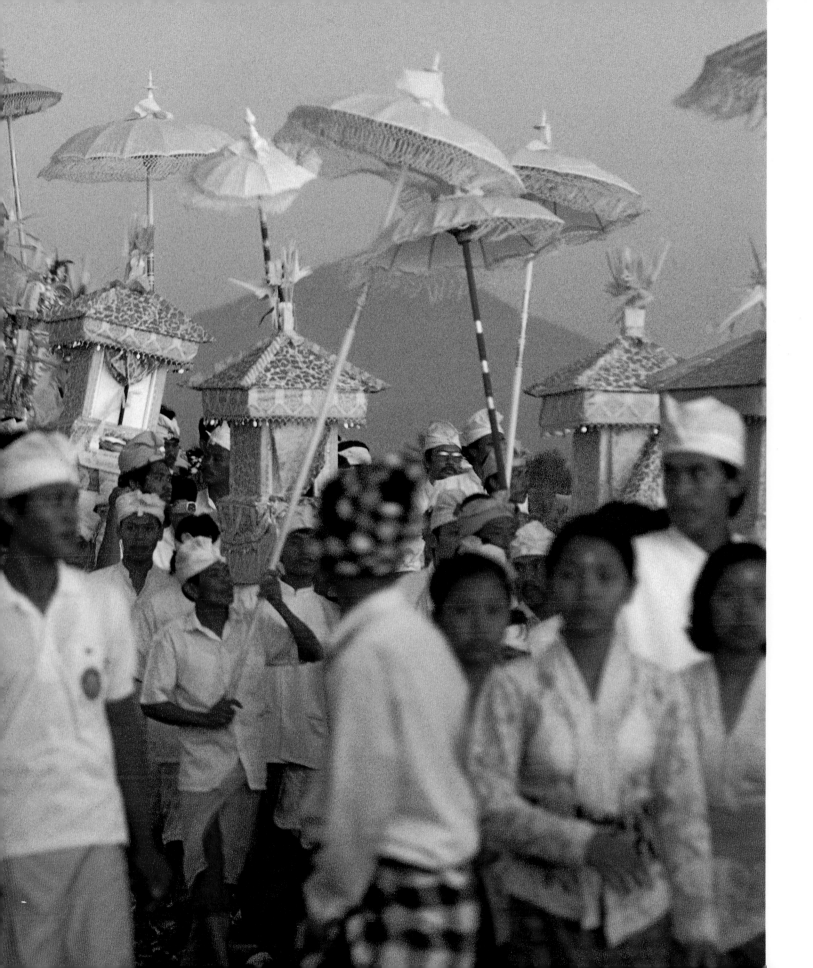

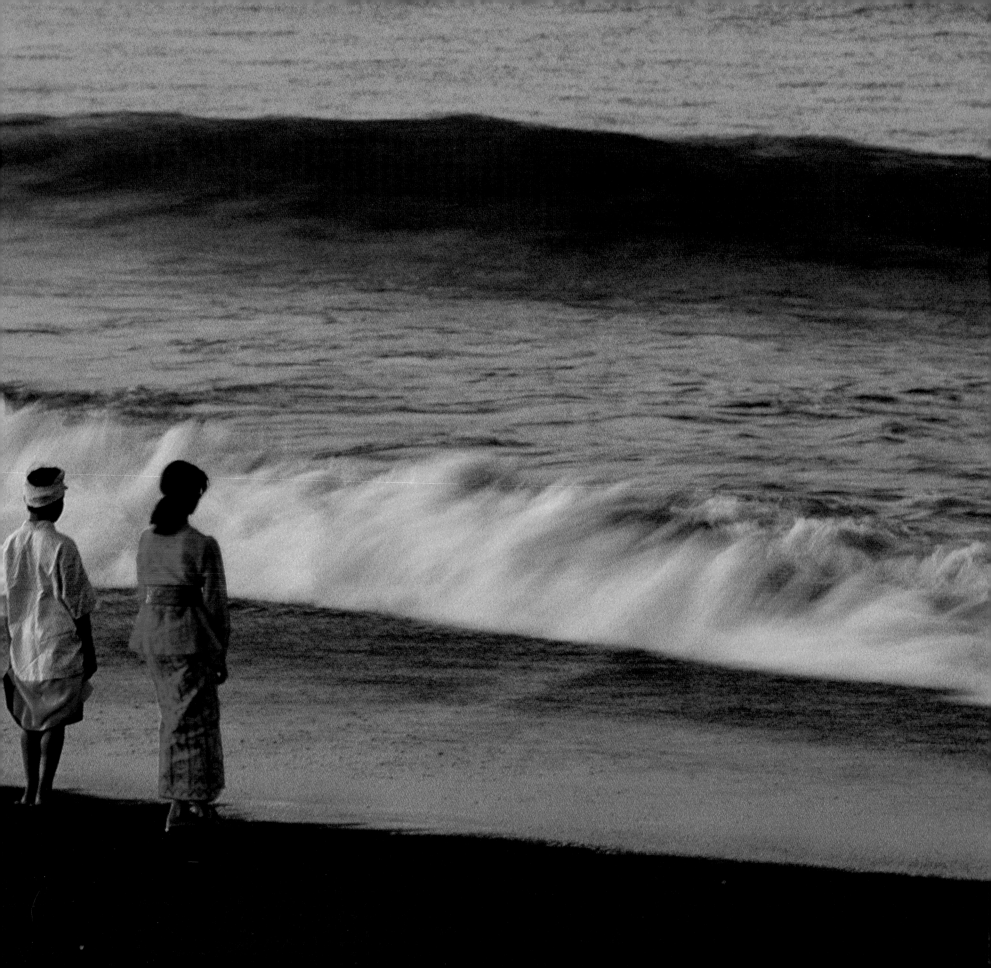

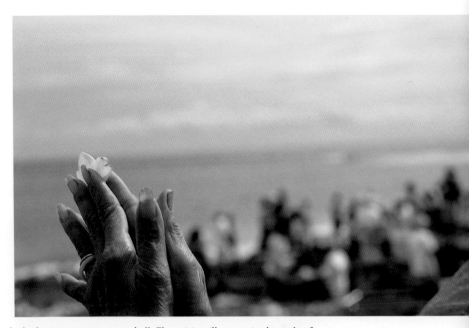

In Hindu philosophy, the body is just a temporary shell. The spirit will return in the cycle of rebirth, turtle perhaps becoming man or higher. The devout make an offering, a prayer for harmony, and collect a portion of holy water, accumulating karma as the life cycle continues.

Next, the purification ceremony, Mapepada, takes place. The core animals, including green turtles, river turtles, geese, chickens, wild birds, cows, pigs, and dogs, are led three times clockwise around the Panataran Agung shrine, constructed solely for this occasion. Dressed in yellow and black, the animals wear the colors of Mahadewa and Vishnu. The goal is to ensure an auspicious rebirth. The governor of Bali takes part.

Finally the climax, Tri Bhuwana, the great sacrifice to regain divinity, harmonize the world, and purify the macrocosm. The animals are led into a sacred enclosure consisting of eleven structures, symbolizing the cardinal directions of the universe. They are killed swiftly, humanely, and the heads are used to adorn the offerings. The sacrifices are intended to raise each soul one notch, to a higher level in the scheme of reincarnation. The number of green turtles used for these rare great events is negligible, unlike the cumulative slaughter I've witnessed for lesser rituals. Nyepi, the following day, is the annual time of prohibitions and complete silence.

Acknowledgments

Thanks to Rolf Bökemeier, senior editor at GEO magazine, whose initial assignment lead to this book project. Thanks also to Christiane Breustedt and Elke Ritterfeldt at GEO in conjunction with this project.

Next, I owe thanks to Ron Holland and Fatima "Mac" Bajerai at Borneo Divers in Sabah, who introduced me to the green-turtle habitat at Sangalakki, and who encouraged and helped me all the way along. I hope the Indonesian government will soon realize the natural significance of Sangalakki and grant Borneo Divers the sole responsibility of protecting it, before it's too late.

I sincerely hope that I have honored the trust of the Indonesians who so warmly accepted me. Special thanks to Marzuki, I Wayan Kerig, Anak Agung Gde Rama, and Ba Tambouli. They have taught and shared many things.

Also, I would like to thank Lyall Watson, Andrew Wilkes, and Roger Gorman for joining me on this project and making it what it is, along with Akihiko Miyanaga and Seiichi Hasumi at Takarajima. Many friends have supported my work, both spiritually and technically, always having time to share for brief and sporadic visits. Thanks to my agent and friend Hiroshi Yasumura, Tanaka-san at Nikon, Lee Chang Nam, Lincoln and Mayumi Potter, Junji Takasago, Tim Porter, Steve Gardner, Charlie Cole, Dave Wade, Rio Helmi, Lorne Blair, Fred Eiseman, Graham and Donna Taylor, Paul Adderley, Michael Hoffman at APERTURE, and Miriam Gross and the New York Public Library for the archival material.

Note: Specific numerical information concerning Pacific green turtles (Chelonia Japonica) refers to observations by the author in East Kalimantan. Data for other regions may vary significantly.

Charles Lindsay is represented by Q Photo International, Inc., Tokyo, Japan.